OFF THE WALL

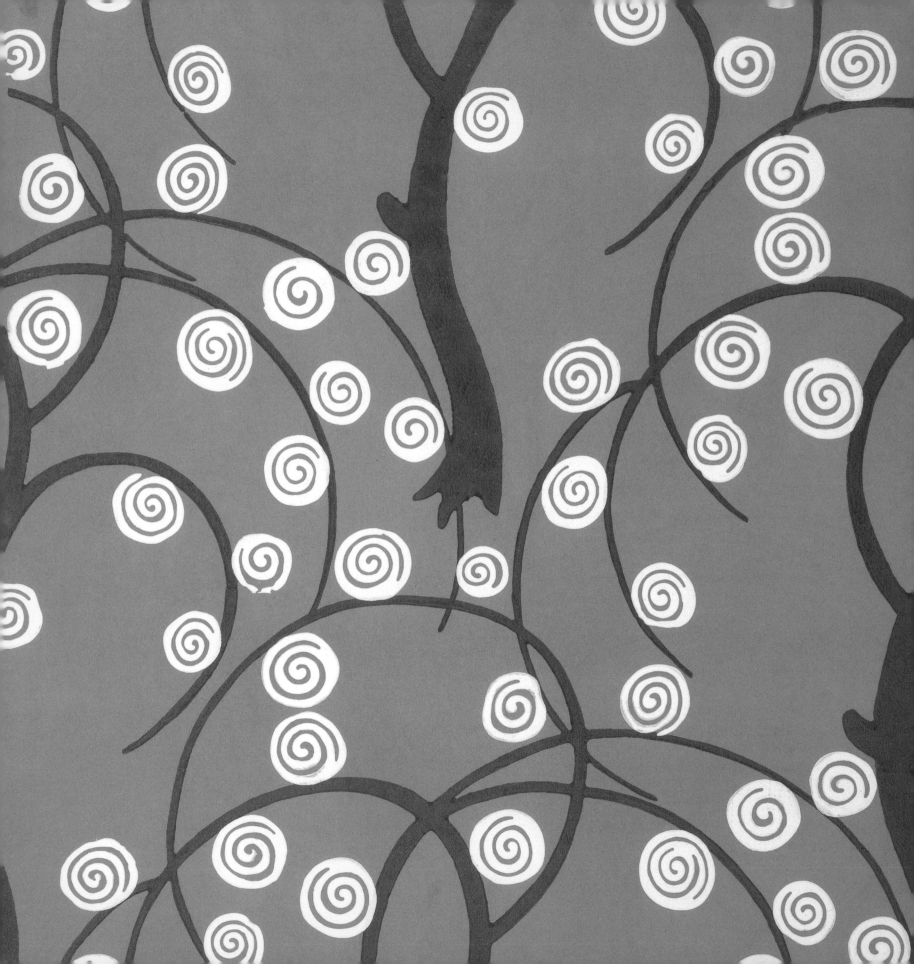

Lena Lenček and Gideon Bosker

In Association with
Cooper-Hewitt, National Design Museum,
Smithsonian Institution

Off the Wall

Wonderful Wall Coverings of the Twentieth Century

CHRONICLE BOOKS
SAN FRANCISCO

To Bibi Lenček, who makes walls sing . . .

Library of Congress Cataloging-in-Publication Data:
Lenček, Lena.
 Off the wall : wonderful wall coverings of the twentieth century / by Lena Lenček and Gideon Bosker.
 p. cm.
 "Drawn mainly from the Cooper-Hewitt, National Design Museum, Smithsonian Institution's extensive collection of wall coverings"—Text.
 ISBN 0-8118-3573-1 (paperback)
 1. Wallpaper—History—20th century. I. Bosker, Gideon. II. Title.
NK3400.L45 2004 745.54—dc21
 2003006743

Page 2: The spiral design of this 1920s wallpaper was machine-printed with wooden rollers fitted with metal, felt-packed strips to which pigment was applied.

Page 6: Designers of the 1950s were preoccupied with bringing nature indoors, as in this mid-1950s American pattern.

Manufactured in China.

Designed by Pamela Geismar
Typeset in Bodoni Poster, Monotype Grotesque, and Electra.
Editorial Consultants: Jill Bloomer, Image Rights and Reproductions; Gregory Herringshaw, Collections Manager, Wallcoverings Department; and Elizabeth Johnson, Editor, of the Cooper-Hewitt, National Design Museum, Smithsonian Institution.

Distributed in Canada by Raincoast Books
9050 Shaughnessy Street
Vancouver, British Columbia V6P 6E5

10 9 8 7 6 5 4 3 2 1

Chronicle Books LLC
85 Second Street
San Francisco, California 94105

www.chroniclebooks.com

Either that wallpaper goes or I do.
—Oscar Wilde on his deathbed

As Leo Tolstoy noted in another context, "We are forced to fall back upon fatalism in history to explain irrational events (that is those of which we cannot comprehend the reason)." In our case, the irrational event was our infatuation with wallpapers, which happened the day we checked into a musty hotel on the Ile Saint Louis in Paris, many, many years ago. The wallpaper in question was a brilliant yellow stripe with a curious monkey pattern running just beneath the ceiling. What the monkeys were doing we no longer remember. But we do recall it had something to do with primping.

Since then, we have studied and appreciated countless wallpaper sample books and papered walls the world over. The impetus for this book came, in part, from our delight with the riotous imagination of wallpaper designers of the twentieth century; and, in part, from the inspiration of wallpaper collections at the Cooper-Hewitt Museum, the Brooklyn Museum, Second Hand Rose, and various private collections.

For their guidance and their help with this project, we want to thank: Joanne Warner, formerly of the Cooper-Hewitt Museum; Barry Harwood, curator, Decorative Arts, Brooklyn Museum; Suzanne Lipshitz, Second Hand Rose, New York, New York; Mary Field, Metropolitan Museum of Art; Dennis and Marilyn Katayama, Portland, Oregon; Mittie Hellmich; and Vicki Brown, Pro Lab Northwest.

At Chronicle Books, we owe a great dept of gratitude to Leslie Jonath, our visionary editor, for steering us through all stages of this labor of love; to Lisa Campbell, for keeping us on track; to Pamela Geismar, for her wickedly intelligent design; to Laurel Mainard, for expertly coordinating all the players; and to Jeff Campbell for his fastidious copyediting.

Finally, we thank, for her patience and support, Bianca Lenček Bosker, who started out her painting career by crayoning on the walls.

Contents

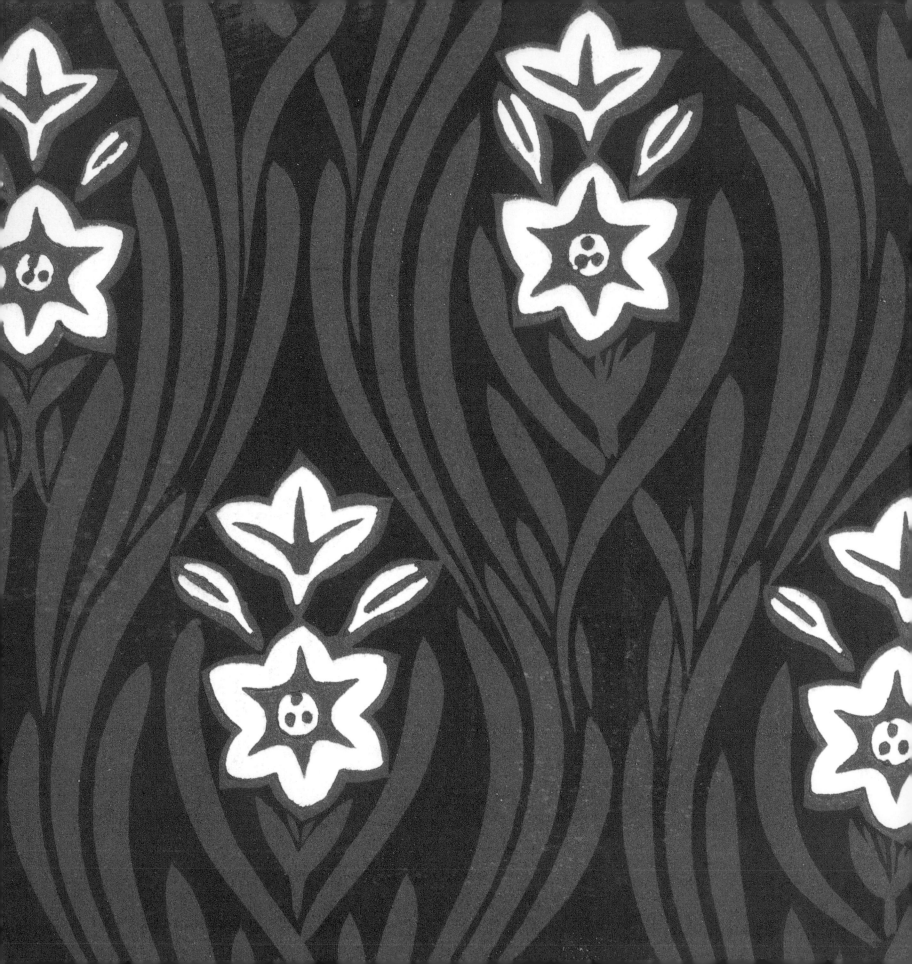

Paper Dreams

HISTORY, DESIGN, AND USE OF WALLPAPERS

The simple, repeating design of this wall-paper from Japan floats white starflowers on a ground of swirling stems and tendrils.

More than plaster, paint, wood, or bare stone, wall-paper is a medium that bears a message. Whether figural or abstract, traditional or avant garde, wallpaper transforms the surfaces it covers into billboards of taste, psyche, and fantasy. In the twentieth century, when mass production, innovative materials, and printing techniques cross-pollinated with an unprecedented fluidity of traditions and designs, wallpaper leapt from its privileged position as a covering for the elite to become the truly democratized and democratizing purveyor of domestic elegance, refinement, and in some cases, downright kitsch. With the unfurling of a roll of paper and the wielding of a glue-sodden brush, a paperhanger could transform a hovel into a seraglio, a boudoir into a nursery, and a bungalow into a Versailles. Thanks to the magic of trompe l'oeil on paper, a claustrophobic corridor could metamorphose into a sunstreaked *allée* of poplars leading to a distant pergola. *Papier doré* and *papier argenté*, stamped metal foil, could transform a dingy toilet into a jewel-box.

Yet, a certain taint of impermanence and inauthenticity attaches to the glorious transformative promise of modern wallpaper. Ever since the mid-eighteenth century, when the craft of handmade wall coverings—from tapestries to textiles and meticulous hand-painted panels—increasingly yielded to cheap, mass-produced, machine-printed papers, wallpaper has enjoyed an equivocal status. Foreground or background, art or

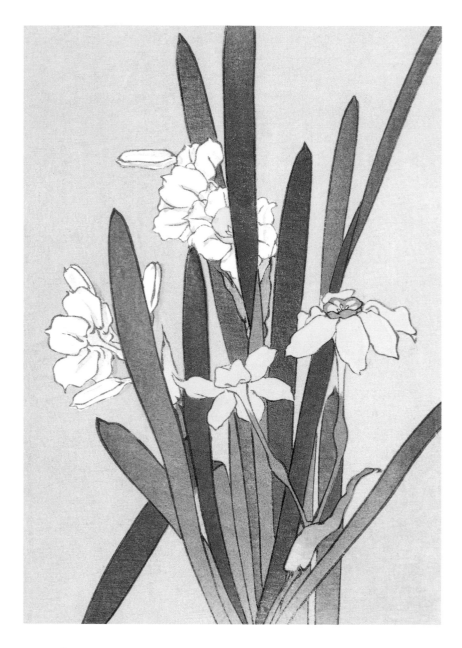

Seven colors are used to lay the delicate tints of the paperwhites featured in this refined Japanese wallpaper.

ornament, tasteful or tasteless, the "thing in itself" or a cheap imitation, wallpaper challenges the taxonomist of design like no other element of domestic décor.

Wallpaper literally dresses interior spaces as expressively as clothes clad the body. Both integuments function as extremely public forms of communication that speak of their owners' cultural sensibilities, private fantasies, erudition, economic and social status, and psychological state. For the papers that ornament the walls of a dwelling provide, in essence, a visual chronicle of taste in flux and an eloquent record of the shifting topographies of domestic utopias.

Like so many appurtenances of the modern home, American wallpaper traces its origins to elite art technologies, takes a detour dictated by brute necessity, and effloresces into a nuanced and rich art form under the pressure of the quintessentially American passion for self-invention and social climbing. Originating in Germany, northern Italy, and the Netherlands at the end of the fifteenth century, the earliest wallpapers were not ersatz murals or faux marbles, but expensive, self-valued artifacts made one small sheet at a time according to the highest standards of graphic printmaking. As such they were important vectors for the dissemination of visual ideas and decorative devices. By the sixteenth century, however, high-quality painted papers began to appear on the ceilings of palazzi, manor houses, and churches where they mimicked more costly materials such as carved wood or murals.

With the introduction of engraved wood blocks that permitted the printing of rolls of paper in distemper colors in the mid-eighteenth century, wallpapers made a critical move from the salons of the aristocracy into the rooms of the rising bourgeoisie. As manufacturing costs declined, so did the prestige of mass-produced paper coverings, betrayed by the simple fact that wallpaper came more and more to be used in the surrounds of windows and doors—in areas, that is, that saw heavy wear and tear and that subsequently necessitated fre-

quent and relatively inexpensive replacement. The modest householders of the Industrial Era—merchants, craftsmen, tradesmen, and laborers—required wall coverings that would make the walls of their abodes appear finished and warm and livable, that would broadcast their social status, and that would not cripple budgets.

Mass-produced wallpapers fit the bill. By the mid-nineteenth century, painted papers, block-printed papers, flock papers, and roller-printed papers originally aimed at the poorer market began to reveal great decorative promise. On both sides of the Atlantic, mass-produced paper coverings emerged not only as an economic and practical substitute for more aristocratic materials but also as a medium for talented painters, engravers, and artists. So it was that the great Arts and Crafts, secession, and art nouveau artists and designers of Europe began to see in wallpaper a tremendous resource for popularizing their elite design ideas and for creating living environments that were "total art works."

In the United States, all along the Eastern seaboard, factories equipped with mechanical presses capable of printing as many as twelve colors at a time, as well as of grounding, satining, gilding, and flocking papers, churned out mind-boggling varieties of wall coverings: from washable "sanitary" papers and imitation leather to commemorative and other pictorials featuring celebrations of historical events and evocations of modest rural pastimes. Costs fell drastically as the nineteenth century moved to a close, and designers hustled to fill a seemingly insatiable market.

Modernity and modernism may have been the rage in Europe at the turn of the twentieth century, but in America, contemporary design during the first three decades of the new century was an oxymoron. Except for a handful of Europeans, interior designers in the United States were largely stuck in the past. The most commonly available wallpapers were fussy Victorian patterns that had gone out of vogue across the Atlantic at least a generation earlier, or they were derivative

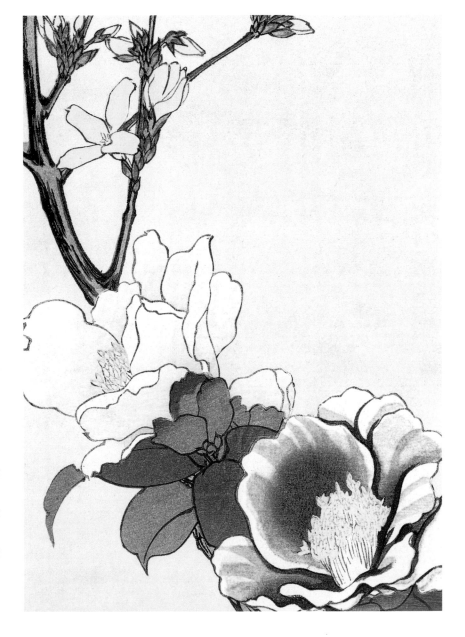

The peony and forsythia design of this wallpaper owes its precise delineation to eighteenth-century botanical drawings.

eighteenth-century designs that gave off a fusty air of respectability and mild tedium. At best, patterned papers tended toward stale floral designs bedaubed in murky tints; at worst, they featured what a contemporary critic scathingly dismissed as "vicious novelties."

Part of the problem could be traced to a growing tendency among the most influential architects and their elite clients to denigrate the cachet of wallcoverings. The preeminently influential Frank Lloyd Wright typified the architectural avant-garde's disdain for concealing the structural and material integrity of walls. In his new "organic" houses he made no provisions for wallpapers, echoing the sentiment of the Viennese Adolph Loos, who in 1905 pronounced all ornament a crime and thereby set the tone for the stark, bare walls of modernist design. For American consumers of wallpapers, the next forty years would largely be a wasteland of secondhand ideas and mediocrity, with the notable exception of the tasteful "Craftsman" or "Mission" papers produced by Gustav Stickley for a boutique middle-class market. Architects and designers for the ultra-rich ceased generating new wallpaper patterns; just as significantly, they also stopped specifying paper as a covering for their clients' walls. Sociologically demoted, wallpaper became the staple of middle-class décor. But while relegated to the backwaters of design, it continued to flourish, its manufacture spurred by the practice of "forced" repapering: every spring, for seasonal housecleaning, and every fall, for the urban rental market.

Early twentieth-century writer Edith Wharton, who in such novels as *The House of Mirth* and *The Age of Innocence* dissected the manners and morals of her class, proclaimed wallpapers not only aesthetically bankrupt for "effacing the architectural lines of a room," but also "objectionable on sanitary grounds." Wallpaper has one major shortcoming: an insalubrious, magnetic attraction for arthropods, insects, and bacteria. Russian nineteenth- and twentieth-century fiction is filled with local color describing the scourge of cheap lodgings whose wallpapers nightly disgorge marauding armies of voracious insect life. The authors themselves experienced this horror in an otherwise respectable rooming house on Chicago's South Side, where, by cover of night, commando units of bedbugs emerged from the seams of wallpaper above the beds to conduct bloodletting raids on our hapless sleeping bodies.

The hidden ecology of wallpapers was apparently well known to tenement dwellers and social reformers at the turn of the nineteenth century. In 1906 the Tenement House Department of the City of New York went so far as to pass legislation—largely unimplemented—to outlaw wallpapers in tenements. This, it was hoped, would eliminate the diseases, germs, and insect infestations that chronically swept through the poorer neighborhoods. Reformers were convinced that grimy tenement walls created hospitable conditions for vermin. And even though landlords scrupulously repapered apartment walls, they rarely got to the root of the problem.

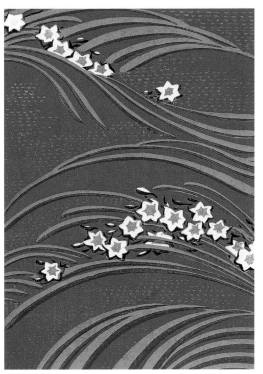

This was because new papers were generally applied directly on top of the old. The cost of redoing a typical, 325-square-foot apartment rarely exceeded a dollar. On the other hand, removing old layers cost considerably more in time and labor. The cellulose in paper, sizing, and paste contains proteins and carbohydrates that attract termites, silverfish, and cockroaches, as well as molds and fungi. Given proper levels of humidity, stagnant air, and dim light, the decomposing old papers and organic adhesives can be transformed into multilayered sandwiches of nutrients for noxious fauna.

 The wallpaper industry has attacked the problem on several fronts, or more precisely, on both sides of the problem: the visible surface and the invisible underside to which the adhesive is applied. Until 1853 wallpapers were printed largely in water soluble distemper paints, which had the double disadvantage of absorbing the pollution of burning oil lamps, gas, and coal and of not being washable. The oil-printed papers that appeared that year were experimental and expensive. Not until the late 1880s and early 1890s did washable wallpapers become available on a commercial scale. These were the so-called "sanitaries," papers printed in oils and coated with size and varnish that made them impervious to water.

 Another "hygienic" wallpaper was invented by Frederick Walton, who contributed linoleum to the world. In 1877 Walton developed a compound of oxidized

The designer of this Sogo Matsumoto wallpaper used a subtle pattern of gold stippling to animate the background for the lyrical pattern of swirling acacia leaves and white starflowers.

This Japanese wallpaper from 1926 relies on Western impressionistic techniques to render clustered peonies.

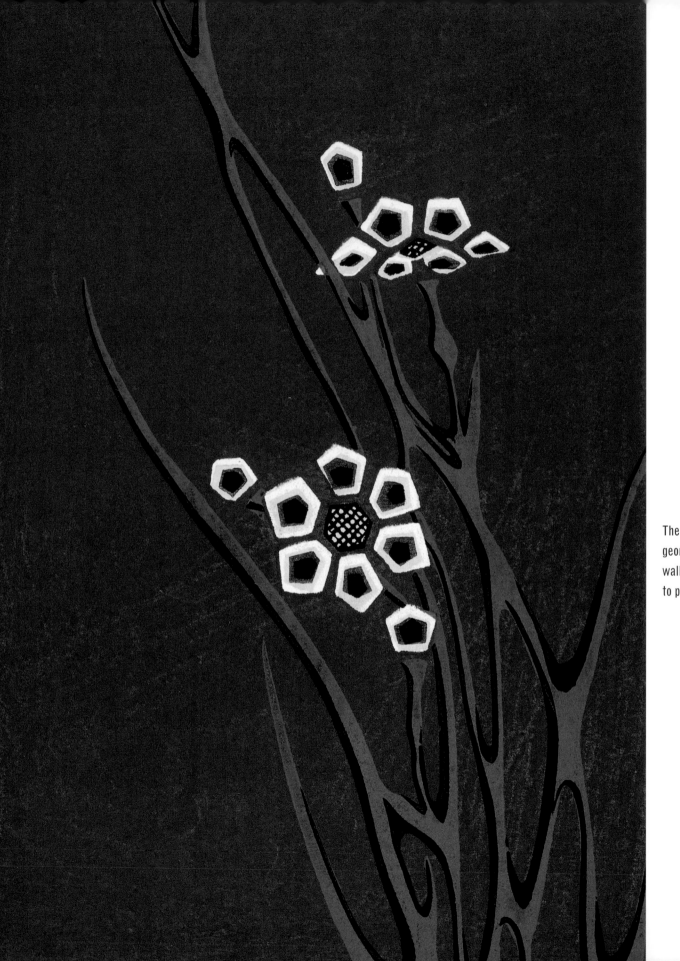

The combination of organic and geometric forms in this Japanese wallpaper from the 1920s is indebted to pottery designs.

linseed oil, gum, resins, and wood pulp that he spread on a canvas backing and then passed between engraved iron or steel rollers. The resulting "Lincrusta-Walton" featured a versatile, paintable, bas-relief surface that was touted to be totally hygienic. Waterproof, it could stand up to ruinous abuse and to cleaning by weak solutions of acid. These qualities made Lincrusta extremely popular as a covering material for the walls of high-wear areas such hallways and stairways, public buildings, railway carriages, and ships. Other "hygienic" bas-relief papers included products such as Anaglypta, Subercorium, Calcorian; the asbestos-based Salamander, and the rag-and-wood-pulp based Lignomur, Cameoid, and Cordelova. Despite the proliferation of brands, however, these hygienic coverings had the disadvantage of expense that put them out of reach to urban tenements and rural homes.

Cellulose-based, biologically "reactive" adhesives, however, remained the staple of the wallpaper industry well into the middle of the twentieth century. Until the 1950s and 1960s, common wheat flour was the most popular and most versatile adhesive medium. After World War II, though, the wallpaper industry was revolutionized by the development of plastic resins, which offered stain resistance and washability, and by biologically less reactive vinyl adhesives, which came to entirely replace wheat paste. Thanks to the technical ingenuity of chemists and engineers, wallpapers of the future will confine animal life to the visible side of the surface, providing only the distractions, inspirations, and delectations intended by their designers and manufacturers.

Even as these practical solutions were plotted in chemists' laboratories, the renaissance in design took on a powerful momentum in the opening decades of the twentieth century. In Paris, Vienna, Munich, and London, some of the most imaginative modernist designers were rethinking wall décor. In England, leading architects and designers such as C.F.A. Voysey,

Lewis F. Day, Walter Crane, and William Morris continued to pour inspiration into their wallpaper designs. The artists of such centers of progressive design as the Bauhaus and the Wiener Werkstätte were pioneering simple and uncluttered geometric patterns, and introducing novel combinations of strong, clean, fresh colors. The new visual terrain colonized by avant-garde artists spread to the applied aesthetic of domestic wallpapers. German and Austrian designers favored bold geometric lines, brisk colors, and cubist-inspired forms. French and Italian masters preferred the loose, lyrical line and soft suggestive colors of impressionist art.

As in so many other areas of post–World War II life, Uncle Sam also gave a helping hand to the American wallpaper industry. During the war years, wallpaper, along with nylon hosiery and rubber swimsuits, was deemed a frivolous nonessential by the War Production Board. Patterns and styles were reduced by an average of 20 percent. The use of critical materials in the manufacture of wallpapers was curtailed by 50 percent, while bronze and aluminum powders were completely eliminated. With the "thawing" of what the *New York Times* dubbed the "design freeze" in November 1945, the wallpaper industry geared up production with a vengeance. During the next two years, Americans bought over four hundred million rolls of paper, a peak to which the industry was not to ascend again in the twentieth century.

Even as the visual range of wallpapers exploded into unprecedented domains, the medium itself evolved at a tremendous pace. Tapping into technologies developed for the military-industrial complex, and the automotive, paint, and textile industries, wallpaper manufacturers steadily improved on the durability, versatility, and installability of their product. Modern processes of manufacture yielded wall-coverings that are waterproof, grease-proof, fade-proof, insect repellent, sound absorbent, and, as if that were not enough, even capable of enhancing the insulating properties of walls.

Sogo Matsumoto of Japan produced this
dramatic wallpaper in 1926.

Yet despite their unprecedented practical advantages and aesthetic range, sometime during the late 1970s, wallpapers went out of vogue. Even by the 1960s, when the war brides and grooms had raised their boomer babies to adolescent rebellion, the output of wallpaper had declined to barely sixty-nine million rolls. Papered walls came to seem old-fashioned, or worse still, déclassé. Despite the introduction of new materials and products and wildly innovative patterns, wallpaper took a decidedly back seat to paint or wood paneling as wall surface treatments.

Some industry insiders blamed the consolidation and downsizing of manufacturers. Others cited the growing popularity of postmodernism with its predilection for retrospective designs. To be sure, production and creativity did not grind to a halt. High-octane design studios such as those of the Italian Memphis group, the British Collier Campbell, the Swedish Tio-Gruppen and Kinnasand, and the Japanese Nuno Corporation continued to push into new aesthetic terrain with high-velocity patterns created with computer technology and digital imaging. But these were too visually ambitious and cutting edge to appeal to a consumer base grown pathologically timid about color and insecure with the supercharged, neo-modern, neo-op patterns.

After a twenty-five-year heyday—from 1945 to 1970—Americans became ever after a nation of wall painters, experimenting over the following thirty years with a mind-boggling range of whites and—after the inevitable onset of white-wall fatigue—with painterly treatments such as hand stenciling, trompe l'oeil marbling, stippling, and sponging. As design historian Lesley Jackson noted, "most people are much more fearful of pattern today than they were fifty years ago." Relatively bereft of pattern, our homes today steer the safe course of calculated coordination orchestrated by mass-market taste arbiters such as Laura Ashley, Martha Stewart, and a plethora of influential home décor magazines. When we approach the task of creating our intimate environment, we fall back on ready-made solutions that do not entirely banish individuality as much as channel it into a limited spectrum of "flavors." Once a vibrant, exciting dimension in our domestic landscape, wallpapers have been relegated either to "safe" heritage patterns or to the marginal spaces of our homes: bathrooms, hallways, and seldom used guestrooms.

But in wallpaper, as in fashion, change is the only constant: today's passé becomes tomorrow's cutting edge. Once again we are craving the imaginative stimulation, the narrative escapes, the whimsical and reliable diversions of wallpapers. It is in the interest of celebrating this extraordinarily rich genre of interior design, which transforms the merely utilitarian wall into a screen for dreams, that this book was conceived. ●

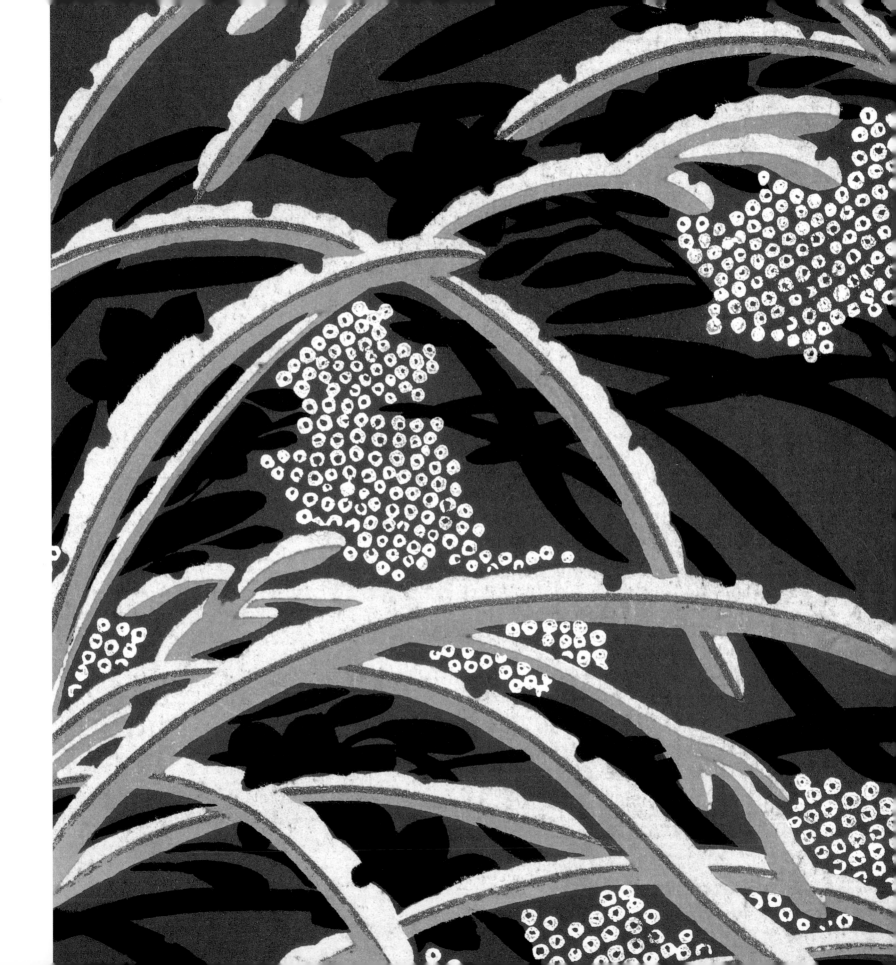

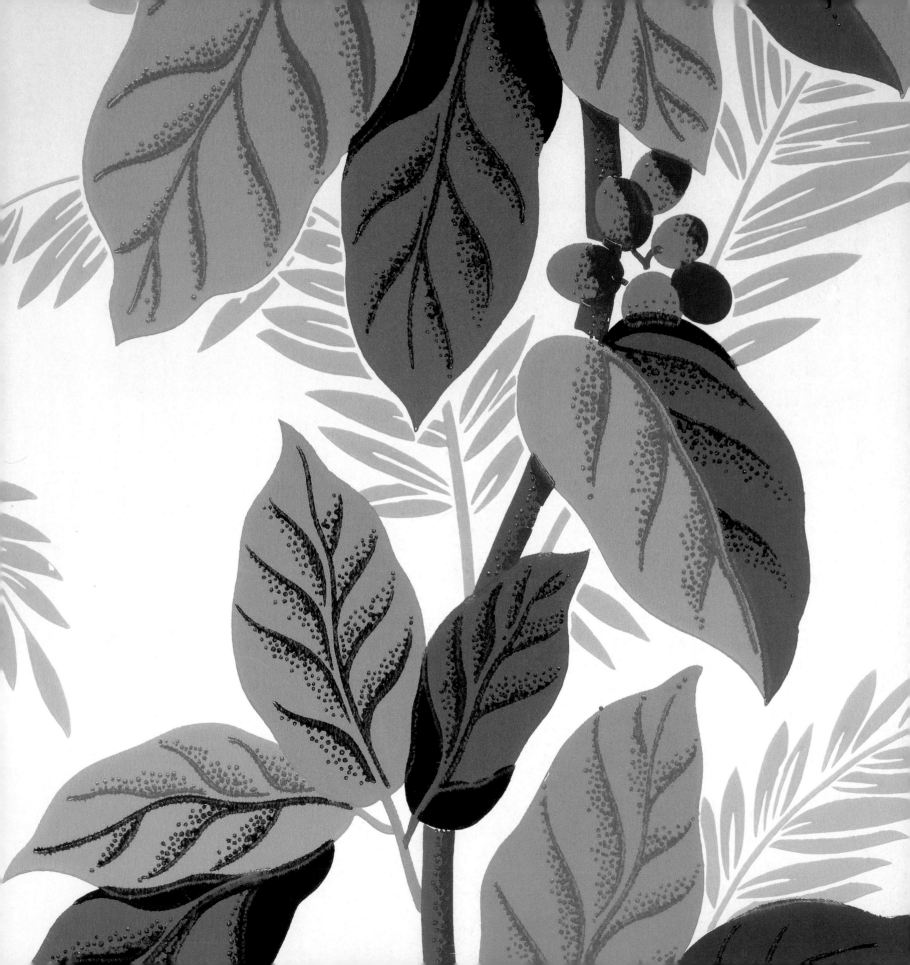

1 *Grand Floral Parade*

BLOOMS, FOLIAGE, GARLANDS, SWAGS

Large-scale foliage creates the effect of a tropical garden.

When the Arcadia of glorious nature lies far beyond a tangle of freeways and concrete, a room blanketed with floral wallpaper provides a ready bucolic setting. In the postwar building boom of the 1950s, vast expanses of farmland were bulldozed over to make room for tract housing and sprawling suburbs, and so designers brought the outdoors indoors. The more standardized the suburban garden—with its regulation square of impeccably manicured lawn, assorted shrubbery, and backyard patio—the greater the range of flora was used to adorn a house's walls: from exotic tropicals to Alpine herbs, from English garden perennials to equatorial bamboos and desert cacti.

This explosion of horticultural exuberance in American taste came, in part, as a manifestation of what social psychologists call "nesting behavior" in response to the trauma of war. After the conclusion of hostilities on the Western and Eastern fronts, demobilized GIs by the thousands set up households with their young brides. The newly minted Adams and Eves seemed determined to transform their bedrooms, kitchens, and dens into veritable conjugal "Gardens of Eden" through the wizardry of wallpaper.

Up to this time, floral designs had enjoyed nearly uninterrupted popularity since the beginning of the eighteenth century, when they were introduced by British manufacturers and suppliers, such as the influential Abraham Price's Blue-Paper Warehouse, James

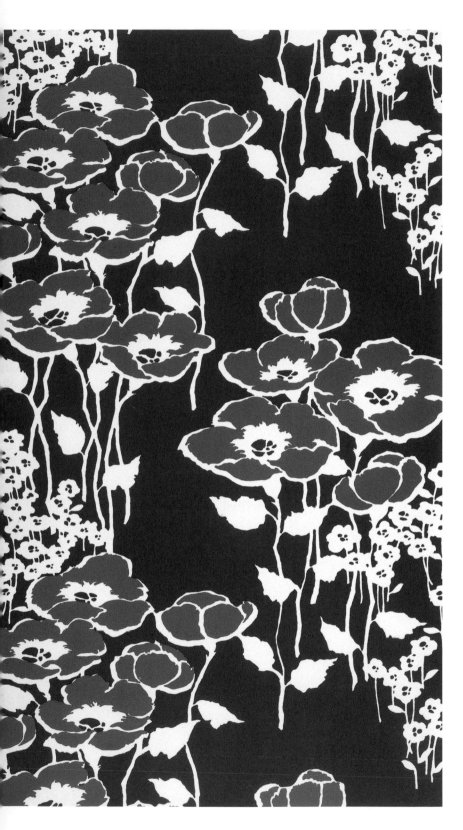

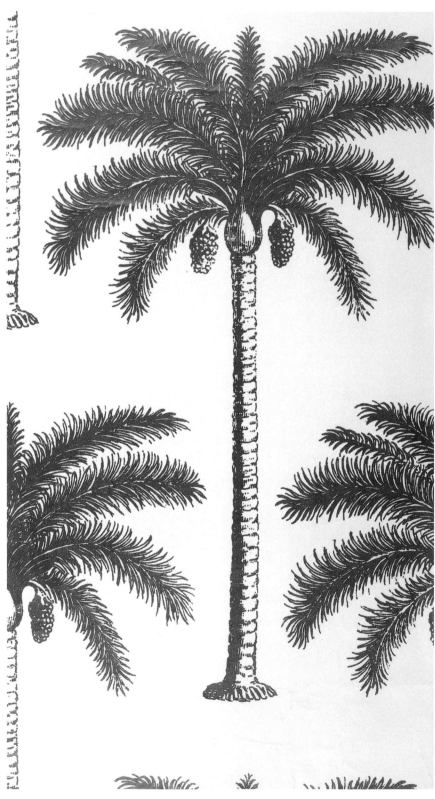

◄◄● "Poppies" by Ben Morris was produced by Hubbell Pierce of New York.

◄● With its lavish use of metallic paint and pronounced vertical arrangement of motifs, "Palm Grove" is characteristic of 1960s wallpaper sensibility.

●► William Morris's widely loved wallpapers drew inspiration from plant forms rendered in such a way as to, in the designer's words, "fill the eye and satisfy the mind."

Wheeley's Paper Hanging Warehouse, and William Armitage of Leeds. Characteristically, the earliest florals from this period feature red-, green-, or blue-stenciled designs in two or three tones against a yellow ground, either plain or detailed with dots laid out in various trellis-like patterns. The least expensive papers combined stenciling with woodblock printing, where the outline of the design was laid on by printing while unskilled workmen stenciled the colors. These popular, if crude, patterns were adaptations of exquisite designs that had been trickling into Western Europe for something under a hundred years, as European travelers, merchants, and missionaries journeying to the Far East brought back with them great quantities of porcelains, glass paintings, and sheets of paper painted with bold designs and intended for the walls of rooms. Painted by master craftsmen, these papers featured landscapes, combinations of birds and flowers, and scenes of domestic life

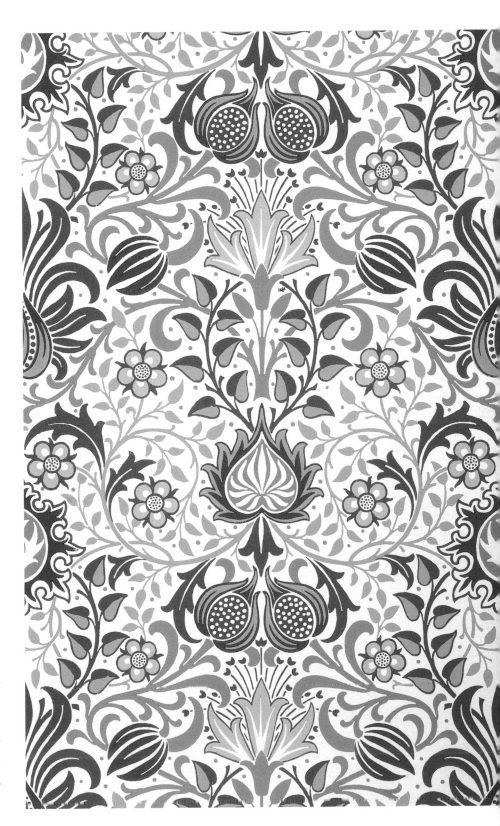

➤➤ The finest floral designs of the 1950s borrowed showy blooms from the repertoire of popular suburban plantings.

⬧ The subtle range of whites and greens creates a harmonious balance in this floral design from the 1940s.

Some of the most appealing designs drew on the especially beloved flora and fauna of Chinese artists during the Sung period (960–1280). The lotus, the peony, and the camellia recurred with the greatest frequency, often in conjunction with such brilliantly plumed birds as the kingfisher, the heron, the partridge, and the parrot. Many of the floral motifs of Western wallpapers were also inspired by Chinese polychrome porcelains that came to be known as famille rose and famille verte, again pairing blooms with birds, cherry blossoms with butterflies, irises with grasshoppers.

By the mid-eighteenth century the technology of reproducing expensive Oriental chintzes and original Chinese painted wallpapers had sufficiently advanced to make excellent and inexpensive copies available. As the fashion for all things "exotic" and "oriental" took hold, imitation Chinese papers invaded the bedrooms and dressing rooms of fashionable ladies, competing with very ornate rococo designs that featured swirling floribunda sprouting from fleshy, scrolling, and scalloped leaves and cascading from bulbous vases and urns. Imitative of costly damasks, the stenciled and block-printed papers combined naturalistic polychrome flowers with abstract floral motifs in white.

During the last quarter of the eighteenth century, blue-ground, pea-green, and gray papers with geometrically stylized, small-scale, and repeating flower patterns, often contained within vertical bands or white-

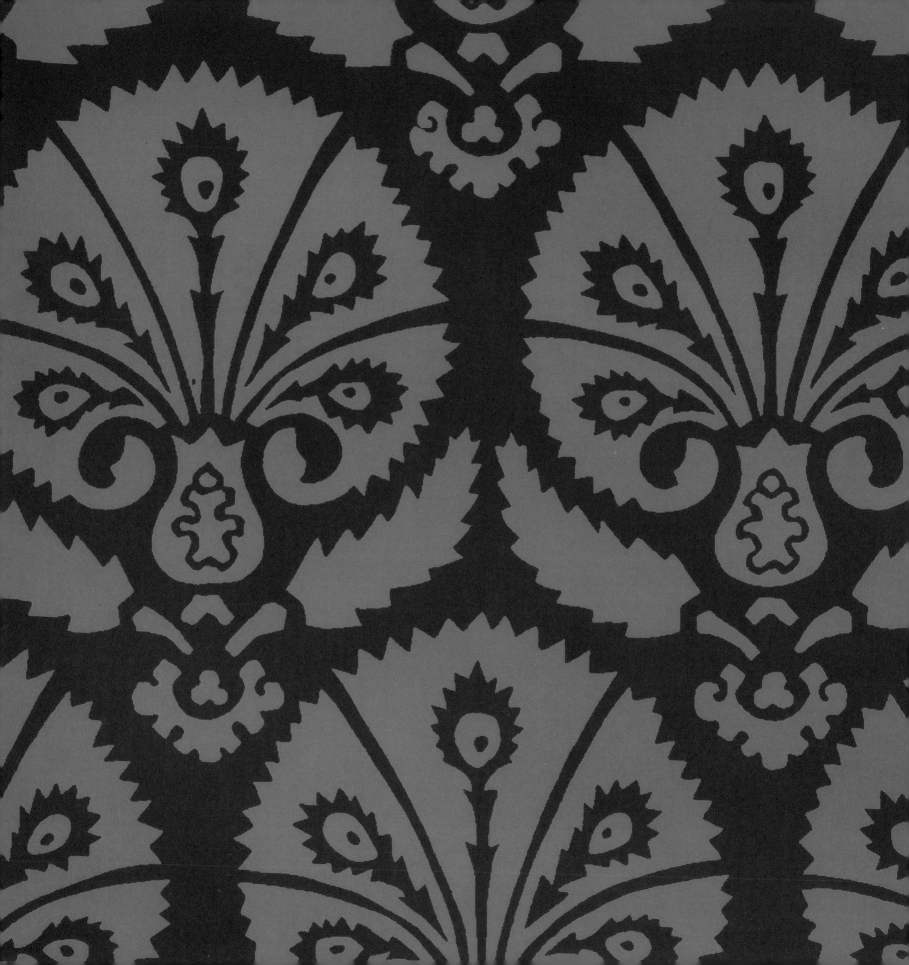

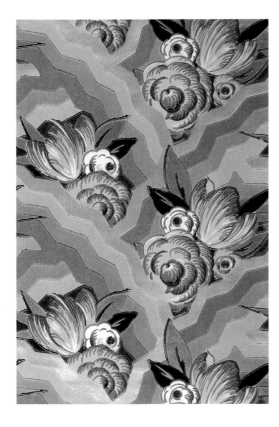
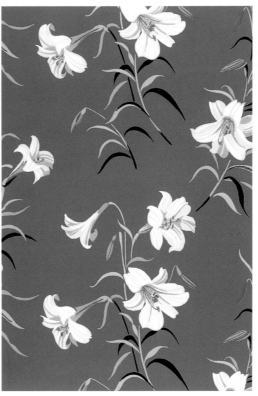
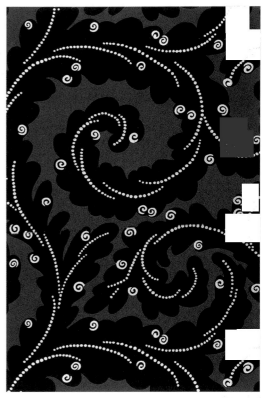

delineated squares, were considered particularly apt choices for bedchambers. The taste for boldly articulated vertical grids ran strong throughout the first three decades of the nineteenth century, either in combination with strikingly realistic reproductions of botanical specimens or, at the other extreme, with highly stylized biomorphic motifs.

As the nineteenth century advanced into the Industrial Revolution, the rage for floral papers seemingly knew no bounds. Keeping pace with prevailing decorating tastes for chintzes, heavy damasks, and prodigious furnishings with elaborately carved vegetal motifs, wall coverings erupted with large luxurious blooms, peonies, brightly colored roses, and abundant grapevines, often with brilliantly plumed birds perched on their branches or taking wing. The more urban the setting, the more botanically escapist the gorgeous wallpaper designs. Englishman William Morris established his firm of Morris, Marshall, Faulkner and Company in 1861 with a rose trellis design with birds, followed up with a daisy motif and, shortly thereafter, a pomegranate print. Morris's floral imagination greatly expanded the repertoire of species considered suitably ornamental for formal use. His papers included the humble thistle, the bachelor's button, the hollyhock, and other uncultivated botanical specimens in a kind of homage to the "natural" garden. Designed either singly or in collaboration with his colleague, Philip Webb (who

🌢 The layering of scalloped bands with floral clusters in this French design from the 1920s shows the influence of Japanese art.

🌢🌢 Atlas promoted the "water resisting" attributes of this attractive wallpaper intended for use in a lady's bedroom.

🌢🌢🌢 This spectacular French arabesque dates from the early 1920s.

◄● Rendered with geometric precision, this 1960s thistle pattern shows the purity of line characteristic of folkloric embroidery.

specialized in drawing birds), Morris's wallpaper designs were distinguished by their atmospheric lightness achieved by floating intertwining floral motifs on a strongly contrasting ground—either light-colored or starkly dark. This device invited the eye beneath and beyond the surface of the pattern, creating a see-through effect that gave the illusion of expanding a room's dimensions. Morris patterns, such as "Horn Poppy," "Blackthorn," "Trellis," and "Bower," continue to enjoy wide popularity in Britain and in the United States, especially among fanciers of the Craftsman style.

In contrast to Morris's understated, polychrome designs, British and American competitors launched extremely ornate and highly stylized papers imitating the gilt leather wall coverings from sixteenth- and seventeeth-century Spain and Holland. These heavily embossed and lacquered papers resembled tooled leather and featured intricate, asymmetrical patterns of formalized flowers and leaves in a variety of metallic finishes upon a faux-leather ground. The most striking in this genre was the Lincrusta-Walton developed in 1877 by Frederick Walton, the inventor of linoleum. Similar in composition to the floor covering, the Lincrusta was composed of oxidized linseed oil, gum, resins, and woodpulp on a canvas backing. This substantial material was not only capable of carrying a relief pattern that could be machine-embossed, but it had the added advantage of being completely waterproof and washable. In this

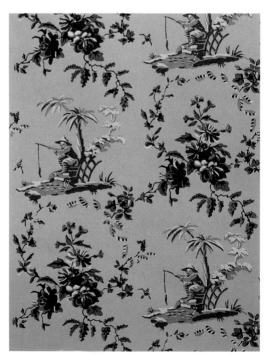

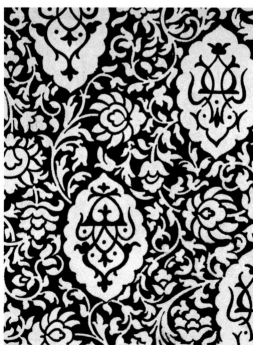

◄◄● The juxtaposition of vignettes of human subjects with images of exotic vegetation is typical of chinoiserie patterns. This French wallpaper from the 1930s substitutes indigenous flowers for the more characteristic peonies or bamboo.

◄● The influence of Indian textiles is pronounced in this wallpaper from 1920s.

●► The exquisitely graceful pattern of swallows and roses on a yellow ground shows the influence of French painter Jean Lurçat.

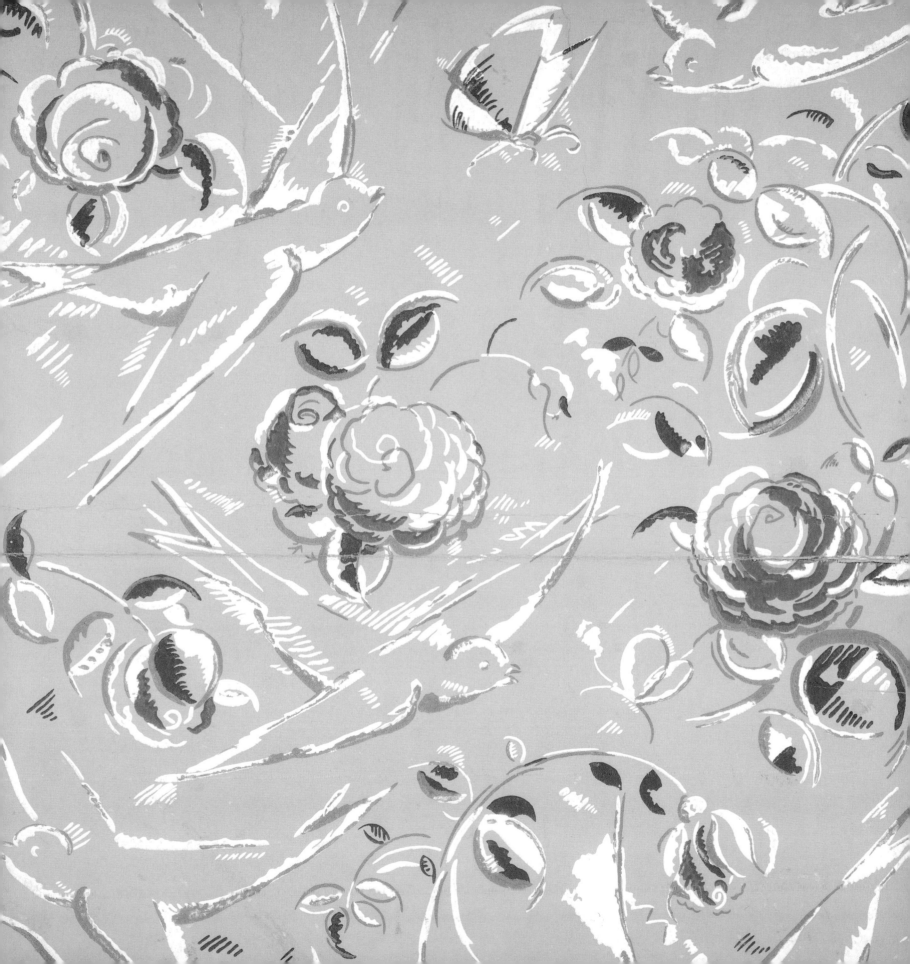

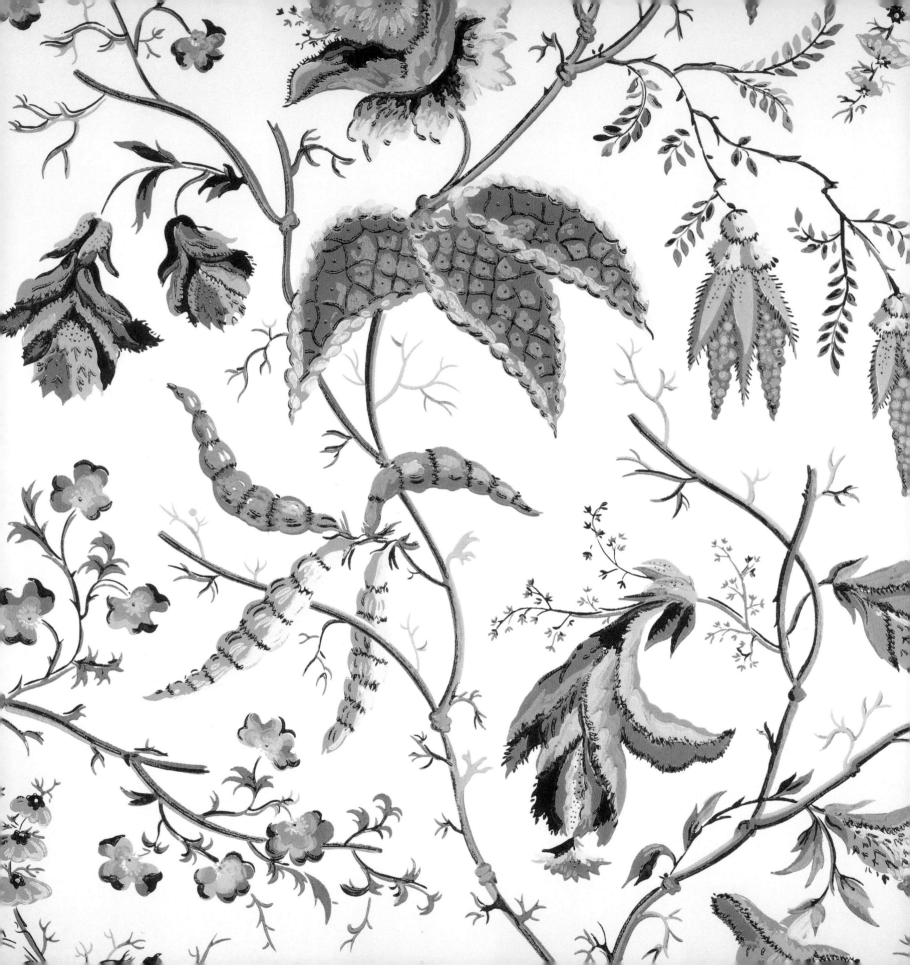

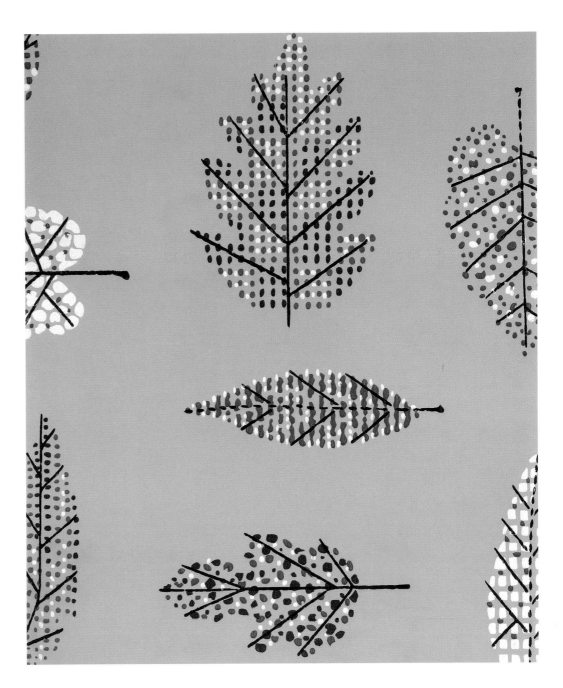

➦ The spare geometric treatment of the 1954 "Forest Patterns" is representative of the contemporary "look" in postwar design.

◂● "East India" is one of the fine historical patterns reproduced by the firm Katzenbach and Warren, Inc.

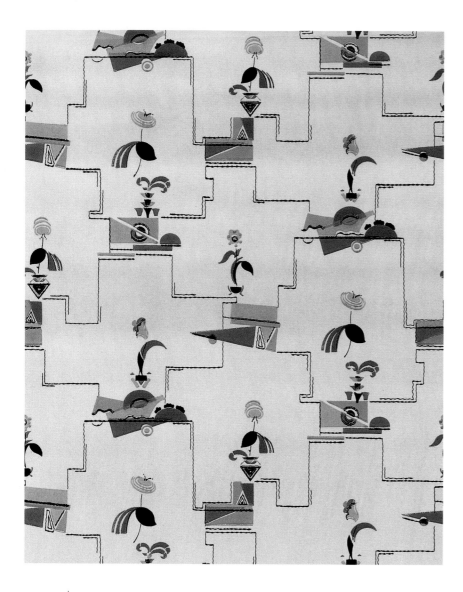

⬇ The papers produced in the 1930s by the Haffelfinger Company of Hanover, Pennsylvania, gave a cubist inflection to floral motifs.

➡ This late 1920s seven-color wallpaper is a hybrid of folkloric nosegays and deco-influenced planters used as repeating decorative elements.

respect it was a superbly elegant alternative to the then-new oil-printed "sanitary" papers, so-called because they were washable without detriment to either color or texture. The aesthetically superior and hygienic Lincrusta proved to be tremendously successful: over a century after its invention, this late-Victorian wallcovering is still available, virtually unchanged.

More than any of the other wallpaper patterns—landscape, geometrics, genre scenes, and novelties—florals gravitate among three sources of inspiration: unmediated nature, textiles, and painting. Whether rendered in photo-realistic detail or the scrupulous fidelity of the best eighteenth-century naturalist illustrators, botanical prints draw on a limitless range of species. Only the taste of an era determines the prevalence of certain eco-niches. If, for the floral imagination of the 1930s, the premier plants were the fleshy ginger bloom, the lushly twining hibiscus, and the tubular gladiolus, in the 1940s the choices ran to poppies, lilies, and camellias rendered with scientific realism. The 1950s and early 1960s tended to favor spiky, spare floral forms. Among the best were those papers designed by Lucienne Day, which have since come to exemplify the aesthetic of the fifties. With their abstracted floral shapes, such hand-blocked papers as "Calyx," "Provence," "Stella," and "Diablo" represented the cutting edge of design. By the mid-1960s, however, the restrained iconography and disciplined palette of Day's vision (and those of her many imitators and vulgarizers) gave way to overpoweringly cartoonish and LSD-inspired hallucinogenic blooms in screaming shades of magenta-orange and hot pink. By contrast, the floral wallpapers of the late 1970s and early 1980s were dominated by simple, stylized patterns in bittersweet colors that hearkened back to the Morris Arts and Crafts aesthetic—in tune with the larger cultural climate of postmodern historical eclecticism. ⊙

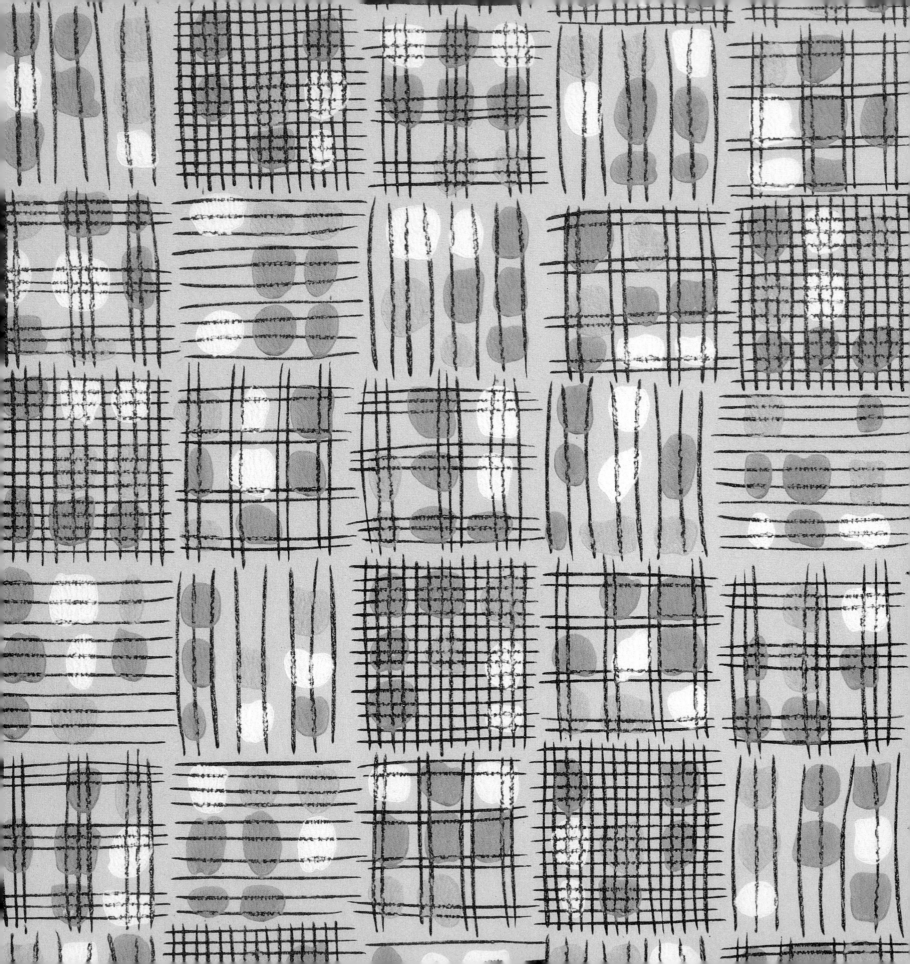

2 Circles and Squares

GEOMETRICS, ABSTRACTS, OP ART, MINIMALIST ART

The repeating motif of grids and dots is typical of the 1950s obsession with exploring the ingenious geometric possibilities of abstract designs.

As early as the seventeenth century, geometric patterns exercised a potent fascination for fanciers of wall coverings. The commonest designs consisted of stripes, diamonds, cartouches—elaborately interlaced lines within a frame—and so-called diaper patterns consisting of diamonds, lozenges, or stylized flower motifs in constantly repeating compartments. The most popular technique associated with these patterns was block printing, an application process that produces a black outline and has remained remarkably unchanged since its introduction four hundred years ago.

In block printing, a design is first drawn on a large sheet of paper the size of the completed panel, then the sheet is divided into squares conveniently sized for the blocks. The design is then transferred to slabs of hardwood, such as that of the pear tree, and carefully carved. The series of resulting blocks are then fitted together and laid face-up in the sequence corresponding to the original drawing. The blocks are inked and a sheet of paper the exact size of the full image is laid flat on them and rolled with a heavy roller. The resulting outline is customarily filled in by various means: by hand with watercolors or tempera, or by the application of paint through as many stencils as are necessary to produce the desired number of colors. In the intervening centuries since its establishment, this protocol has remained fundamentally unchanged, despite innovations in dyes, grounds, papers, and printing. For instance, color printing machines were in universal use by 1854.

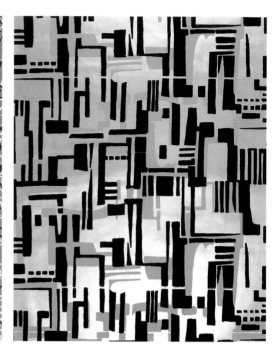

⬧ German wallpaper manufacturers in the 1950s and 1960s called on art schools to contribute "contemporary" designs, such as this low-toned geometric pattern.

⬧⬧ Lamartine Le Goullon designed hand-printed abstract and stylized patterns, such as this one dating from the 1950s.

⬧⬧⬧ The 1960s saw an explosion in technological innovation as space-age surfaces such as vinyl and Mylar were added to the repertoire of materials and coatings, and ways were found to secure natural materials—canvas, hessian, corks, woods, and woven grasses—onto paper backings.

➤➤ A pattern by Hosel Tapete demonstrates the spidery drawing style typical of the early postwar years.

Abstract geometric designs enjoyed little cachet until relatively late in the history of wallpapers. Only with the advent of nonrepresentational painting in early-twentieth-century modernism did inorganic, simplified forms find an appreciative public, as consumers recoiled from the horrors of Victorian excesses such as monstrously convoluted moldings, contorted scrolls and leaves in violent colorways, heavy suffocating drapes. The revolutionary "less-is-more" gospel of the Dessau Bauhaus design school attacked ornamentation for its own sake and extolled rational functionality as a conduit to enlightened living. In 1923 Walter Gropius, the school's director, announced a utopian agenda of shaping "a decidedly positive attitude to the living environment . . . avoiding all romantic embellishment and whimsy."

And what "high" artists started in the ateliers of Montmartre, Moscow, and Munich, the "applied" artists of interior design brought to fruition in mass-produced décor. Cubist and suprematist shapes, most commonly in the form of overlapping squares or intersecting oblongs, made their way into wallpaper patternbooks of the early 1920s. The modern sensibility of art deco, introduced in Paris in the 1925 Exposition Internationale des Arts Décoratifs Industriels et Modernes, took the world of domestic design by storm. Sharing the hallmarks of geometry and simplicity and combining vibrant colors with starkly articulated shapes, deco wallpaper designs celebrated the rise of commerce and technology, the triumph of the machine and of the machine-made. Wheels, cogs, gears, wedges, and streamlined swooshes found their way into the American pictorial vocabulary of the Roaring Twenties.

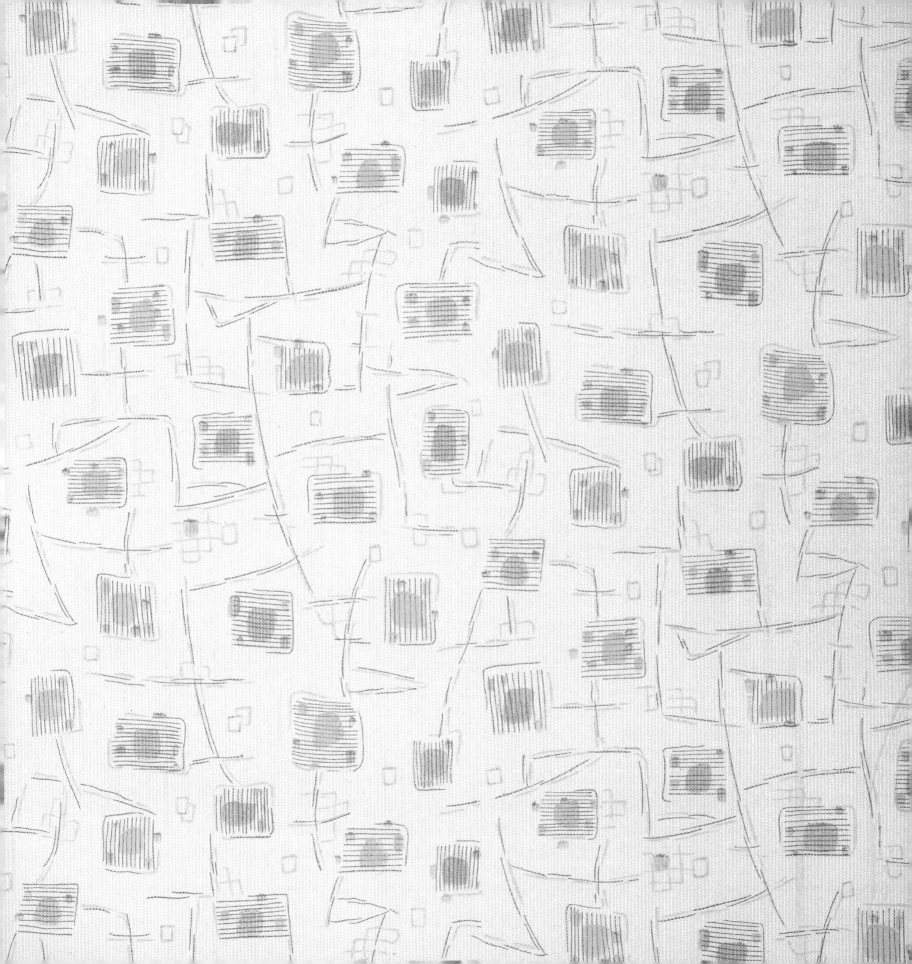

◆➤ This block-printed, non-colorfast wallpaper dates from the 1920s.

⚑ Jean Lurçat's "Les Mazeries" was one of five papers featured at the Salon d'Automne in 1924.

Ironically, however, the innovative patterns of industrial inspiration appeared at an inauspicious time. On the one hand, the grinding economic stagnation of the Depression put a brake on domestic construction and decoration. On the other, the aesthetic prejudice of modernism preached against the use of ornamentation in design. Surface decoration was to be provided by texture rather than pattern and color, and preference was given to such "industrial" materials as concrete, plaster, and glass, which were more in keeping with the concept of the home as a "machine for living." In this equation, wallpaper carried a connotation of frivolity, waste, and old-fashioned fustiness.

Nevertheless, as the economic doldrums receded, the American public once again developed an appetite for more opulent and imaginative surface treatments. Decorating magazines such as *Better Homes and Gardens* and *House Beautiful* showcased interiors papered in tastefully designed contemporary patterns, many of them the work of European refugees from Germany and Austria. Tommi Parzinger and Ilonka Karasz, designers for the firm Katzenbach & Warren, were among the Europeans who promulgated large-scale, simple geometrics. Severe cubist shapes of mathematical precision were often paired with stylized vegetal or floral sprays, the combination carrying a sensuously cerebral—even hygienic—vision of the modern home. Nothing crowned the success of these designs more dramatically than the New York World's Fair of 1939. As a venue for futuristic design, the installations of this exhibition proved vastly influential, tutoring professionals—architects and interior designers—as well as laymen in the tremendous possibilities of nonrepresentational patterns.

With the advent of relatively low-cost and flexible screen-printing in the post–World War II decade, American wallpaper design entered a new era of experimentation that greatly favored avant-garde "modern" patterns. As defined by the *New York Times* in 1948,

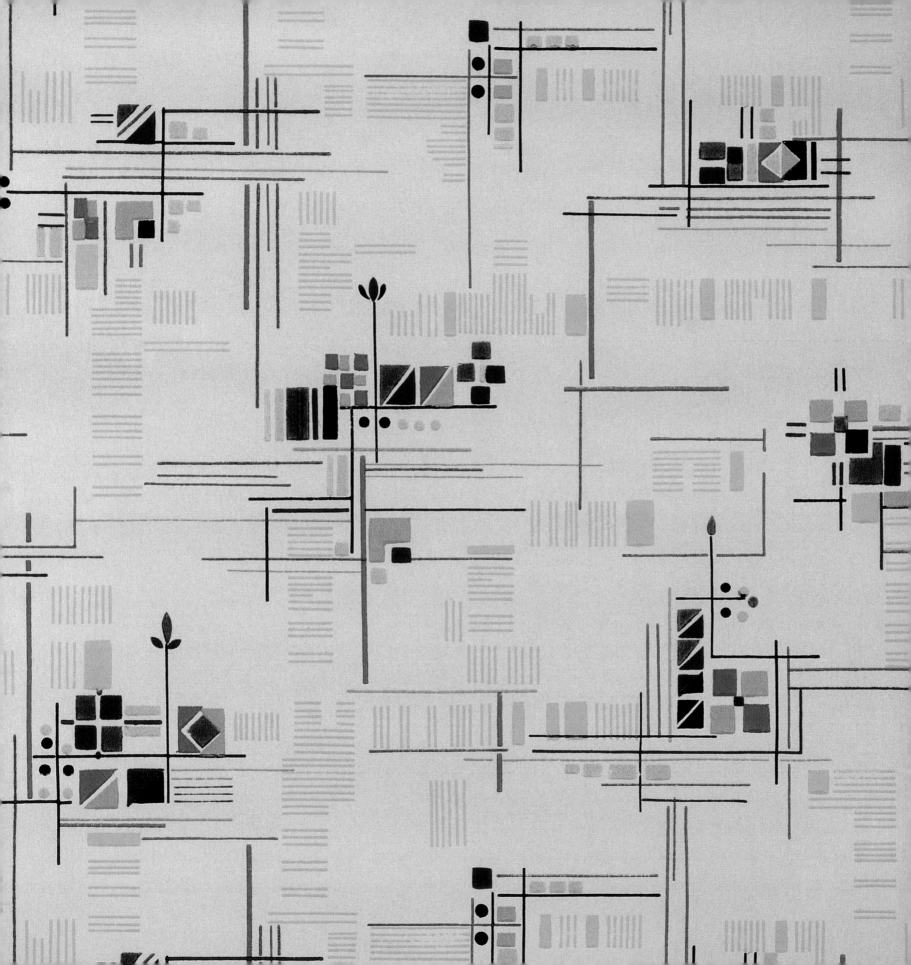

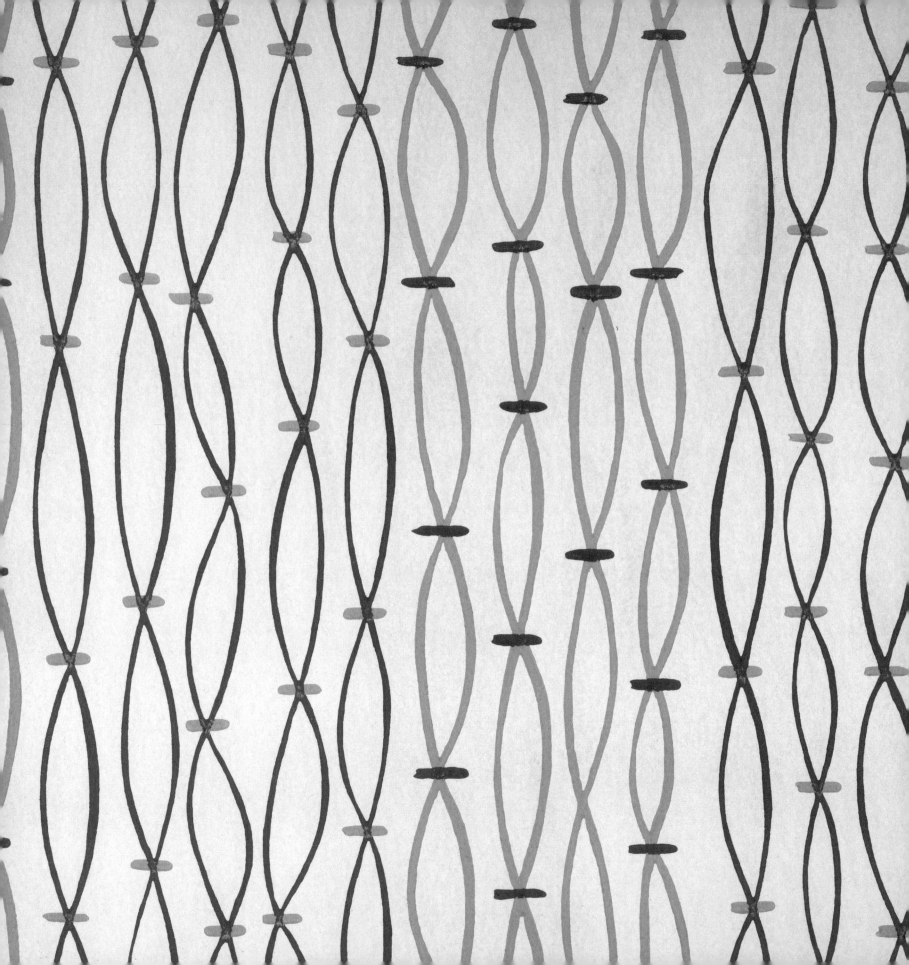

The pronounced rhythmic pulse of this elegant design from the early 1950s shows the influence of British designer Lucienne Day.

these could embrace everything from "a straw mat or a spider web, an abstract symbol of rain, or again a single flower, larger, more brilliant than any that grows in a garden. One thing . . . [modern design] definitely is not: the old familiar line-up of morning glories or plumes marching up and down and around the walls in endless repeat." The wallpaper industry catered to the upwelling of "modern" one-story, open-plan houses—the "ranch" homes of the 1950s—that defined the mushrooming suburbs of postwar prosperity. To counterbalance expansive "picture windows," designers offered boldly patterned papers to be used on a single wall. Featuring large swirls, amoeba shapes, sound wave patterns, and diagrammatic representations of the atom, these designs anchored the living space and provided the dominant idiom from which the rest of the room's furnishings took their cue. In 1949 Schiffer of New York commissioned a group of artists, architects, and designers such as Ray Eames, Salvador Dalí, and George Nelson to produce a collection of modern fabrics. The group generated patterns deemed appropriate for modern interiors: prisms, vertical graphs, Miró-inspired doodles, stylized flying saucers, and loopy loops. So successful were these textiles that the following year the company launched coordinating wallpapers.

In the taste revolution of the 1950s, high and low art institutions paved the way for mass acceptance of modern design. Cinema, television, and color photography broadcast the new look of the stylish home. In shaping this vision, the New York Museum of Modern Art played a decisive role. Starting in 1950, and running for the next five years, MOMA, in conjunction with the Chicago Merchandise Mart, organized a series of "Good Design" exhibitions showcasing the "most courageous and progressive" work in the home furnishing industry. The winning entries were permitted to carry a label that immediately identified them as representatives of "Good Design." The Herman Miller Company, avatar of modernist furnishings, produced a number of wallpapers bearing the MOMA imprimatur, including industrial designer Alexander Girard's abstractions in his signature orange-on-white and magenta-on-gray color combinations.

Heightened public awareness of design encouraged manufacturers in the 1960s to seek more direct inspiration from contemporary art movements. As the art de jour was of the retina-searing pop and op art varieties, the newest—often vinyl, metallic, and neon-colored—wallpapers moved into totally unprecedented visual terrain. In 1966 pop artist Andy Warhol silk-screened his own wallpaper with a cow motif. His effort was downright dowdy in comparison with the assaultive op art design "Razzmatazz"—a black flocking, vibrating geometric on a white ground—by William Justema, produced by the Stamford Wallpaper Company in 1967.

Nothing since has come close to the excesses of the incandescent, eye-fatiguing effects of the 1960s. Geometric patterns in the ensuing decades of the twentieth century—with the exception of computer-inspired patterns of the 1980s and 1990s—were largely historical revivals of Arts and Crafts, secessionist, and art deco patterns, demonstrating, once again, that there is nothing new that is not, in some sense, a resurrection of the old. ◉

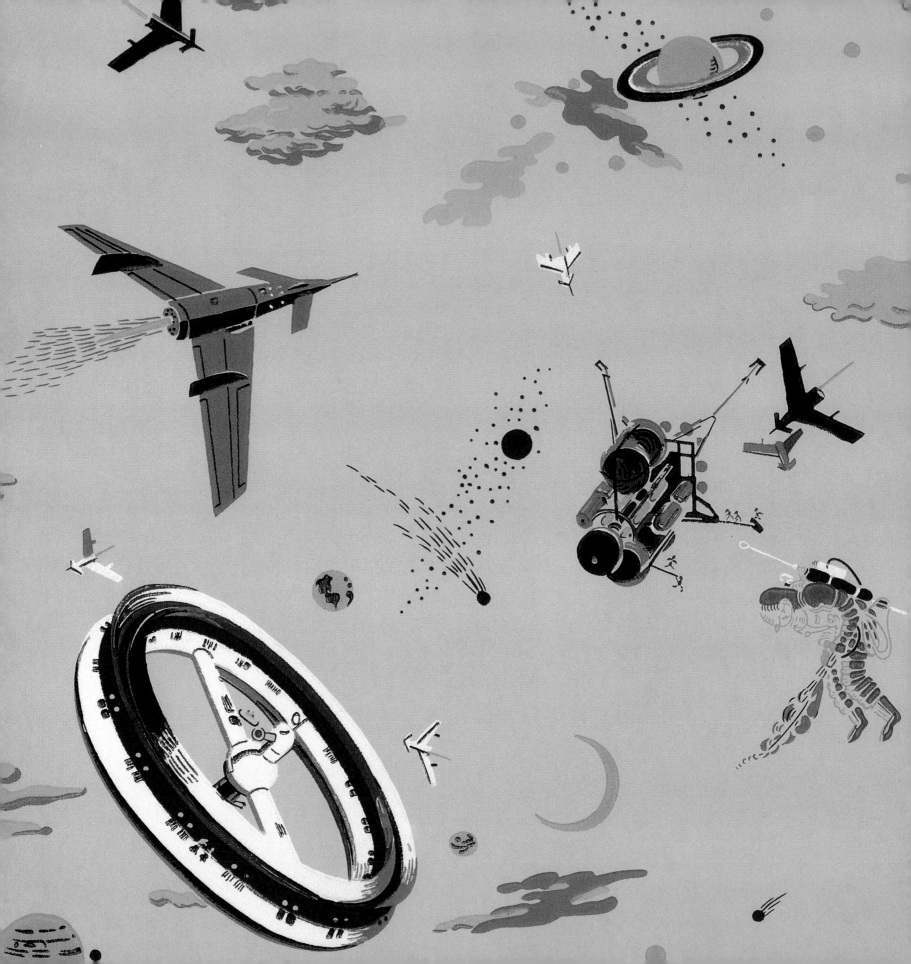

3 *On the Go*

BY LAND, SEA, AIR AND ...
INTO THE WILD BLUE YONDER

"Space Ship," a Crowell Collier Publishing Company design for the Child-Life Wallpaper Company, commemorates the achievements of extraterrestrial exploration.

American society is predicated on dynamism, change, and motion. Our colloquial speech bristles with idioms of mobility: we are always "on the move," "on the road," "up, up, and away," "outta here," restless and yearning for something better just beyond the next turn in the road. Call it incurable romanticism, blind ambition, or hopeless escapism: our compulsive wanderlust runs so deep that even our most characteristic icon of the family home, the quintessentially suburban split-level ranch, is nothing more than a garage with a house tacked on. Pride of place goes to the family car and the Airstream-cum-speedboat parked in the driveway—and to wallpaper designs that pay homage to perpetual motion. Emblazoned on the walls of little boys' bedrooms and their fathers' dens, the machines of escape—boats, planes, and trains; cars and motorcycles; rockets and spaceships—celebrate humanity's historical liberation from bipedalism.

The fascination with vehicular motifs did not begin with the invention of the internal combustion engine. British eighteenth-century wallpapers pioneered mechanical iconography in the form of assorted chariots, rickshaws, barouches, and phaetons. Early in the nineteenth century, rail travel inspired images of trains and locomotives. One particularly striking example from the midcentury depicted a panoramic sequence of panels featuring diminutive trains passing through a pastoral landscape. Very popular by the end of the century

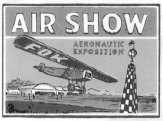
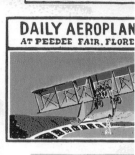
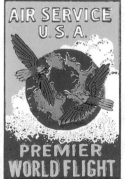
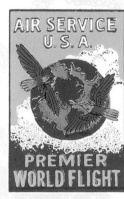
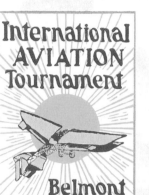

◄● Air show posters over the decades are superimposed on a white ground imprinted with blue clouds.

●► This 1940s wallpaper was inspired by the work of French graphic artist and illustrator Géo Ham (Georges Hammel), known for his dynamic posters of automobiles, car races, ocean liners, and airplanes.

were papers ornamented with scrollwork-framed medallions of steamships, railway bridges, automobiles, and various mechanical and engineering feats. Often these were rendered in grisaille, a monochromatic painting technique using shades of gray. In this period, vehicular imagery was frequently showcased on friezes that were applied between ceiling and wall, surmounting a striped or discretely figurative wallpaper.

But it was the twentieth century that witnessed the true proliferation of mechanical designs and imagery. Spurred by the example of the Italian futurists Filippo Marinetti, Gino Severini, Giacomo Balla, and Umberto Boccioni, European and American artists jumped on the bandwagon of speed and mechanical power. "We affirm that the world's magnificence has been enriched by a new beauty: the beauty of speed. A racing car whose hood is adorned by great pipes, like serpents of explosive breath . . . is more beautiful than the Victory of Samothrace," announced the Futurist Manifesto of 1909. In Soviet Russia revolutionary artists

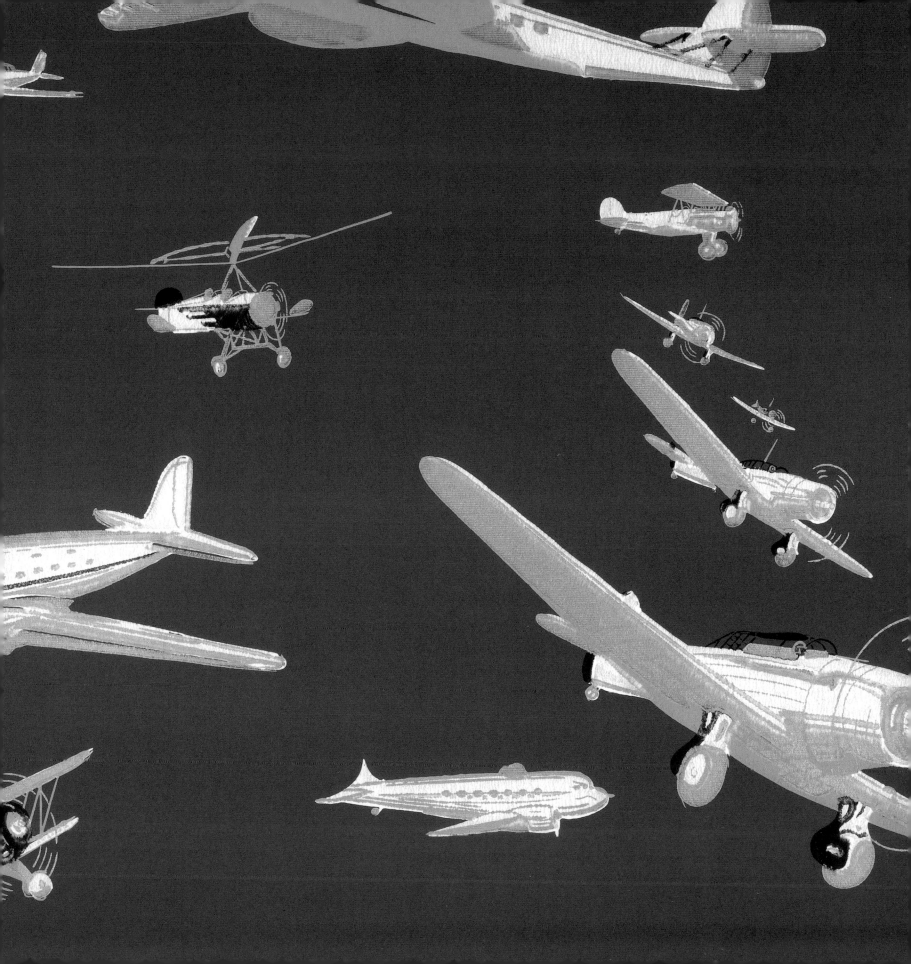

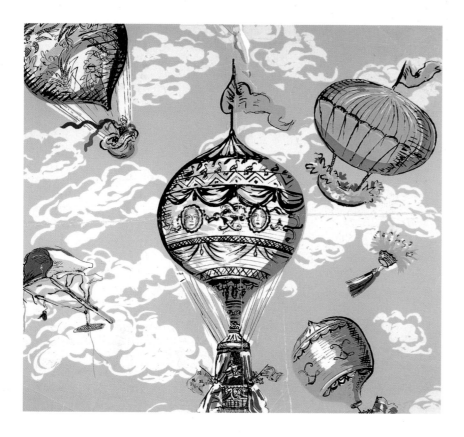

◄● This airy composition of hot-air balloons was designed by Portia LeBrun and hand-printed by Piazza Prints of New York in 1958.

●► Designed by Jean Lurçat for Pierre Chareau, this unusual French wallpaper from 1923 celebrates the military prowess of the victorious Allied forces in World War I.

incubated forward-looking designs for mass-produced consumer products that would bring the glad tidings of change and modernity into every corner of domestic life. Textiles, ceramics, and wallpapers were to serve as screens on which the new revolutionary state would project images of its utopian project. Talented constructivist designers such as Daria Preobrazhenskaia, Alexander Rodchenko, Varvara Stepanova, Liubov Popova, Sergei Burylin, and Vladimir Tatlin sketched prototypes for textiles and papers ornamented with tractors, trains, automobiles, cranes, dirigibles, and airplanes. Alexander Vesnin issued the call to industrialize not only the production but also the "look" of consumer goods: "The contemporary engineer creates objects of genius: the bridge, the steam engine, the aeroplane, the crane. The contemporary artist must create objects equal to these in their strength, tension, and potential." For artists and designers on both sides of the Atlantic Ocean, the automobile, the luxury oceanliner, and the airplane replaced the female nude and the flower as the most potent fetish objects.

In the interval between the two World Wars, the futuristic aesthetic of Streamline Moderne inspired the most progressive building designs for spaces devoted to transportation: bus depots, airports, train stations, and marinas. Hotels in resort settings capitalized on the

romance of travel with upholstery, drapery, and wall treatments patterned with the sexy aerodynamic lines of such signature travel machines as the Clipper, the Twentieth Century Limited, the Grayhound Bus, and Raymond Loewy–designed automobiles. These images were a powerful antidote to the gloom-and-doom of the Depression decade, promising a fully automated utopia of labor-saving machines. The curves, teardrops, and sweeping horizontals featured on the friezes, dados, cornices, and bas reliefs of countless long-since-demolished edifices echoed and amplified the motifs rendered on murals, posters, and wallpapers. Among the best patterns of the style were those based on the illustrations of such Continental and American masters of the Moderne idiom as A.M.Cassandre, Willem Ten Brock, Robert Downs, Norman Fraser, and Leslie Ragan.

In the second half of the twentieth century, however, the charm of these modern icons faded. In the powerful surge of sixties nostalgia for all things organic and natural, manmade machines were swept aside in favor of floral and vegetal patterns. In addition, psychedelics replaced machines of escape. Once emblems of mature and vibrant masculinity, images of the automobile, airplane, train, and spaceship have been relegated to the nursery and the bedroom of the adolescent male. To our ironic and post-Freudian eye, their once-potent imagery now more often suggests a compensatory braggadocio with a powerful dose of playful camp. ●

→► Vintage roadsters are featured on this linen-ground wallpaper from the late 1960s.

♀ "Teen Time," a paean to American adolescence, depicts teens and their obsession with boats, cars, sports, and music.

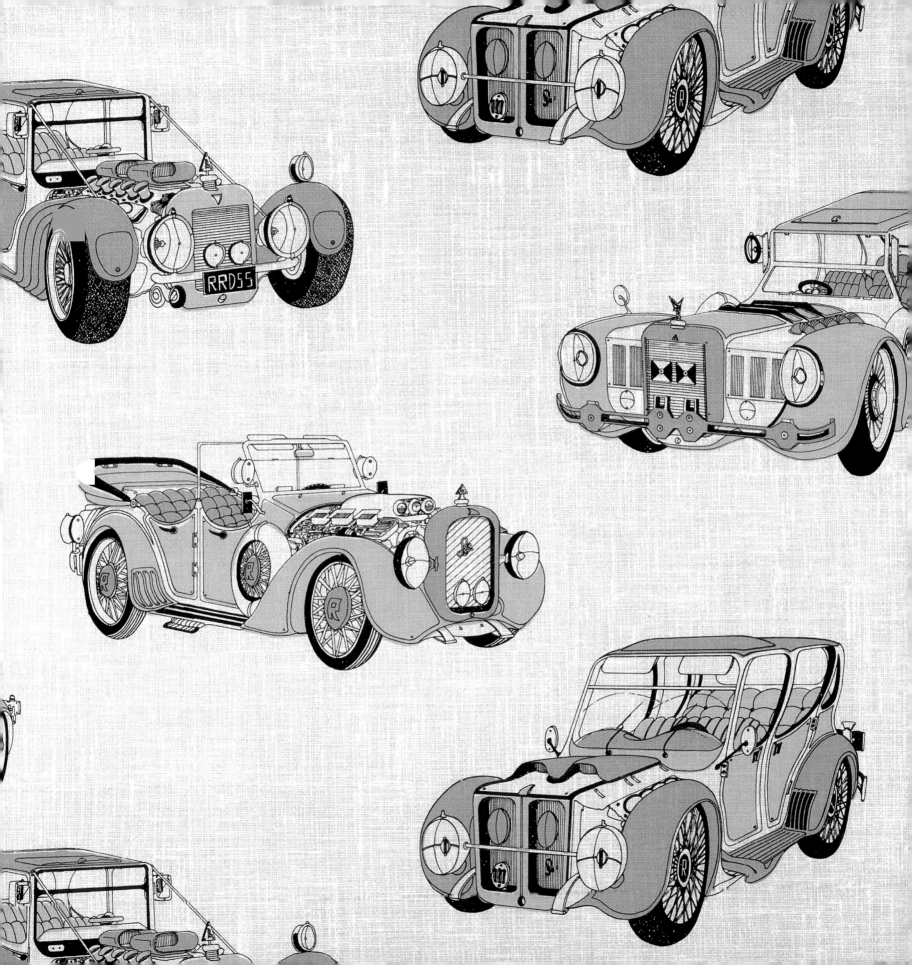

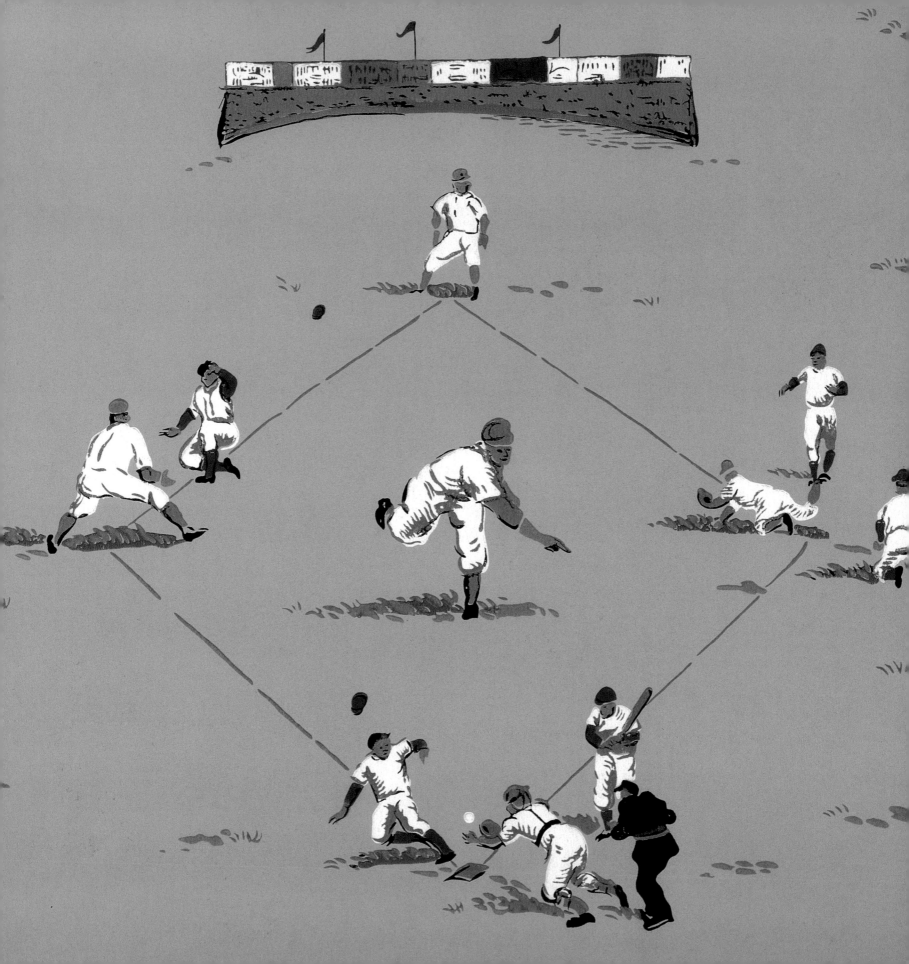

The Sporting Life

ATHLETICS FROM A TO Z, AND THE COUNTRY LIFE OF YESTERYEAR

"Play Ball," a novelty design by Champanier for Child-Life Wallpapers, makes the baseball diamond motif work overtime as a grid pattern.

The life of the body claims its rightful place among the images colonizing our walls. Contemporary wallpapers present an utterly mind-boggling array of athletic pursuits in the form of murals, repeating patterns, and decorative friezes. From anachronistic, elite subjects—such as huntsmen riding to the hounds—to populist themes like bowling, baseball, and boating, the entire spectrum of contemporary sports fills the pattern books of wallpaper manufacturers. Every NFL team logo is represented in its distinctive colors as a frieze. Thanks to designers' and manufacturers' attentiveness to the vanity of professional and amateur athletes, every item of sport paraphernalia—helmets, bats, gloves, balls, shoes, goggles, straps, racquets, nets, baskets, and caps—has been accommodated on some snappy expanse of wallpaper. To go with friezes emblazoned with team names, there are wallpapers with color-coordinated stripes. Portraits of sports greats and near-greats parade in photographic reproductions or cartoon caricatures. Panoramic murals, in living Technicolor or in muted grisaille, re-create Arnold Palmer golf courses, NASCAR races, and NFL games in the wrenching drama of the final minute. There are papers of anglers, hockey players, swimmers, motorcycle racers, soccer stars, skiers, windsurfers, and of course, surfers. Nor must one be limited to the playing field: there are even panoramic, life-size, trompe l'oeil renditions of locker rooms, complete with untidy piles of sportswear and

◄● With its expressive calligraphic lines across sweeping fields of color, the kite was an icon of post–World War II cultural optimism.

●► Rec room culture, circa 1950, is evoked on this Glencraft Imperial wallpaper.

discarded clothing, illusions that have nearly aromatic completeness.

Here and there, a stylized, abstract evocation of some athletic pursuit can be found as an exception to this pervasive documentary vogue. "Fun to Run," a zestful design inspired by Henri Matisse, is one such outstanding example. Produced by Laverne Originals in 1948, the pattern of leaping red, brown, and green figures bounding across a yellow ground avoids the usual literal-mindedness of sport-oriented wallpapers. In recent years, as the number of sports-based designs has multiplied exponentially, so has their aesthetic merit declined. Contemporary pattern books are overrun with largely mediocre, cliché-ridden commercial imagery celebrating every sport under the sun.

With the exception of botanical designs, one would be hard-pressed to find a genre of wallpaper design that inspires a more compulsive degree of exhaustiveness. Manufacturers have left no discipline behind, nor neglected any leisurely or recreational pursuit. Since the late 1920s, with the rise of health cults and the popularity of seashore vacations, manufacturers have developed wallpapers that also reflect the holiday spirit. The 1920s maritime influence was particularly marked in nautical motifs featuring sailors in

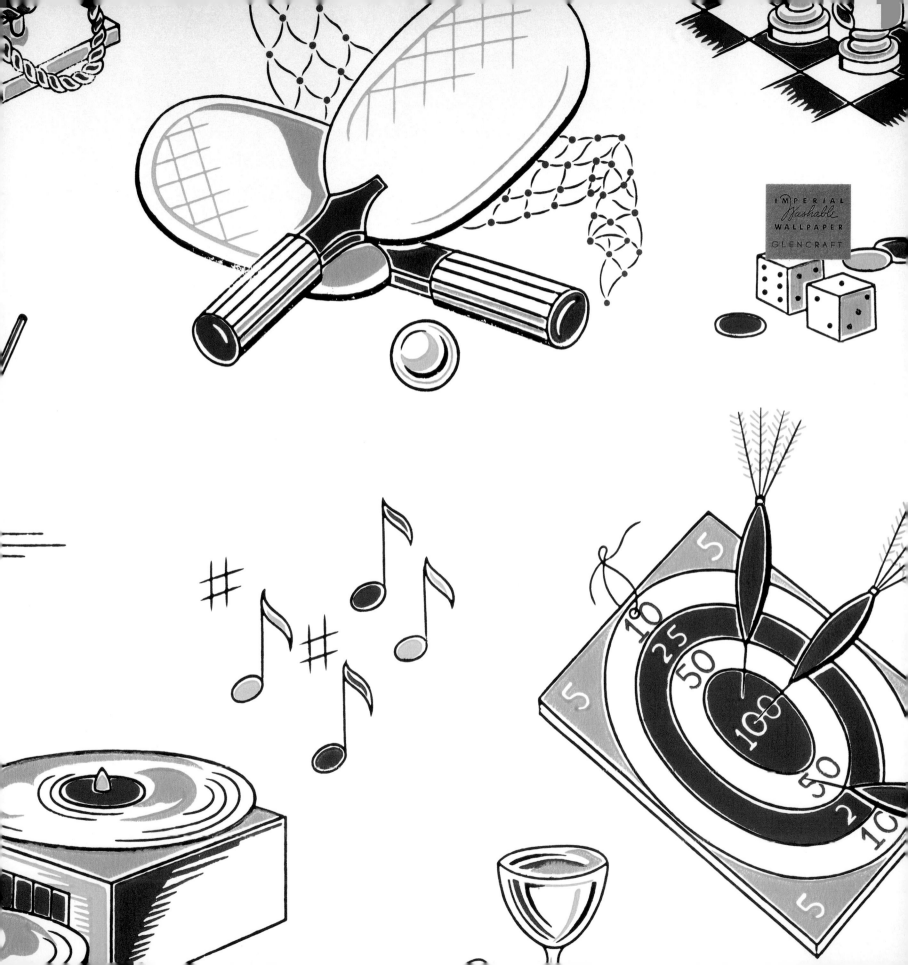

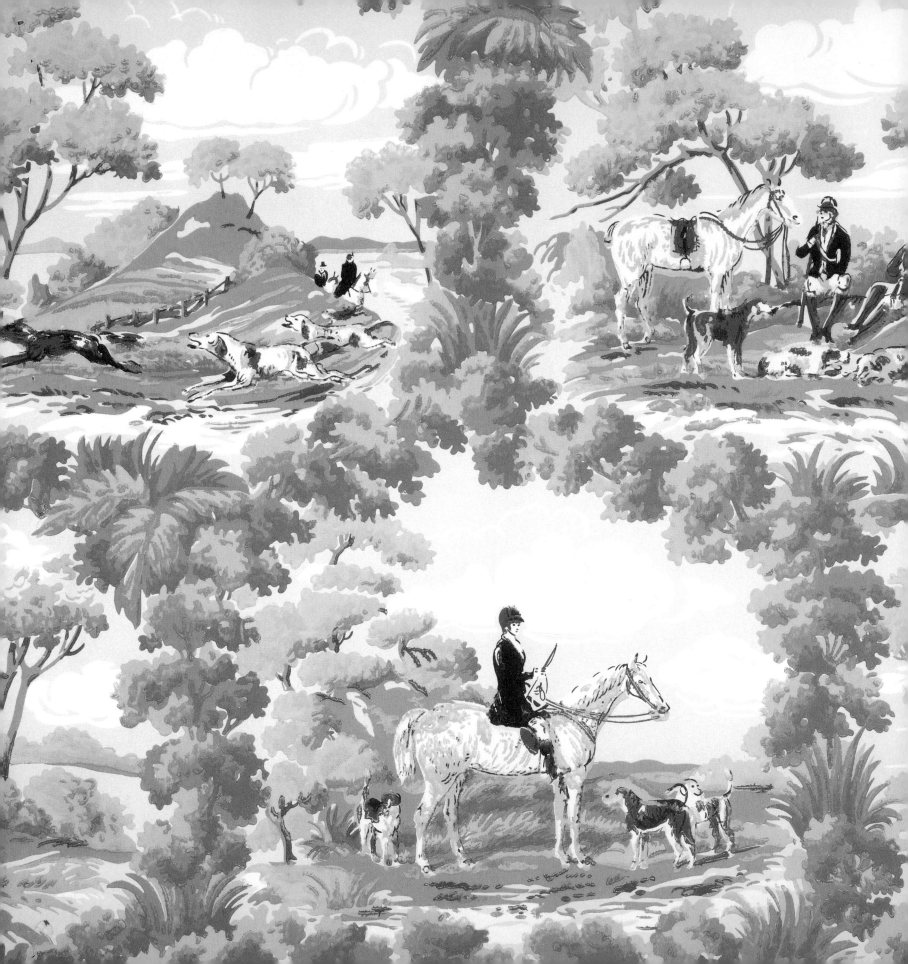

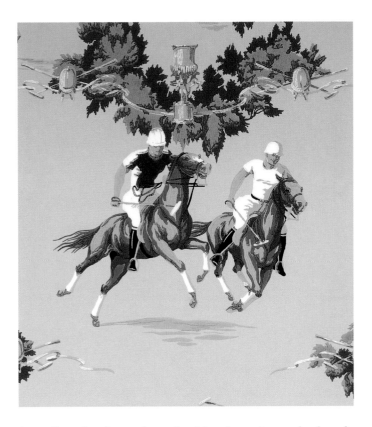

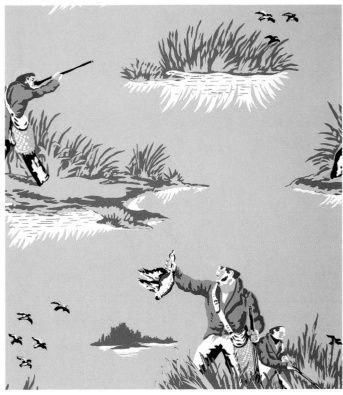

jauntily striped matelotes, bathing beauties under beach umbrellas, yachts scudding over waves. By far, the tricolor red, blue, and white led other cheerful color combinations as the signature holiday color scheme. These recreational scenes were joined by images of submarine flora and fauna. The most diverse examples of piscatorial vitality, from sea horses and jellyfish, to koi and jewel-tinted denizens of coral reefs, appeared on wallpapers intended largely for bathrooms.

The range of pleasurable activities testifies to increasing expanses of leisure time, or a desire for the same. Other papers invoke a moral formal tone, such as images of Greek statuary engaged in ancient Olympic contests. Harking back to the manly art of the chase, scenes of fox hunts and pheasant shoots carry a distinctly "heroic" connotation that makes these papers suitable for masculine spaces like the paterfamilias' den, the library, or the gaming room. Realistically rendered equestrian designs fall into the same category. Fleeting thoroughbreds with tiny jockeys and such

⬧ "Polo," a design from 1949, preserves the attention to detail of fine book illustration.

⬧⬧ The translucent blue ground of "Duck Hunters" recalls the fine hand-tinting of nineteenth-century panoramic wallpapers.

◄● Scenes of a traditional foxhunt appear amid a grid of shrubbery and foliage.

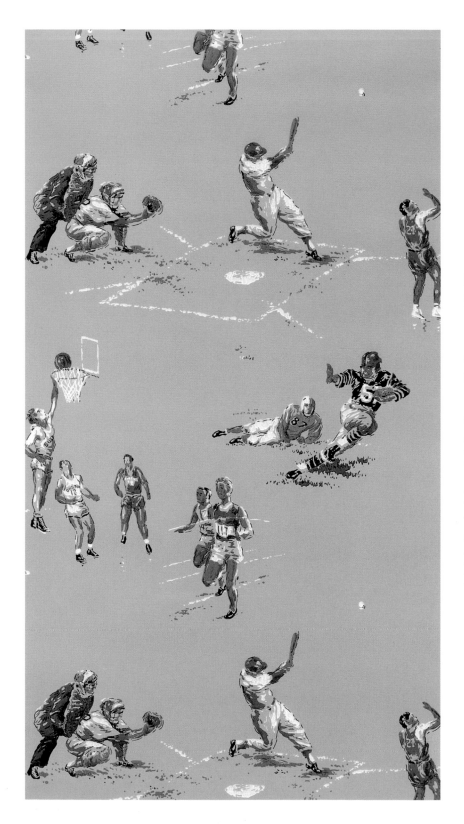

◄● This seven-color, surface-printed wall-paper of high school sports has an embossed, pebbled surface.

●► A tribute to testosteronal prowess in athletics, this 1960s wallpaper captures peak moments in high school sports.

accoutrements of the hunt as English saddles, riding crops, hunt caps, and tall boots reference the sport of kings and bespeak aristocratic pretensions.

Team-sport-emblazoned wallpapers, on the other hand, celebrate the collective spirit even while putting the room's resident squarely in the middle of the action. Call it freeze-frame-in-the-round or instant-replay-writ-large, either way, action wallpaper creates the fiction of life as a game, as a 24-7 spectacle. ●

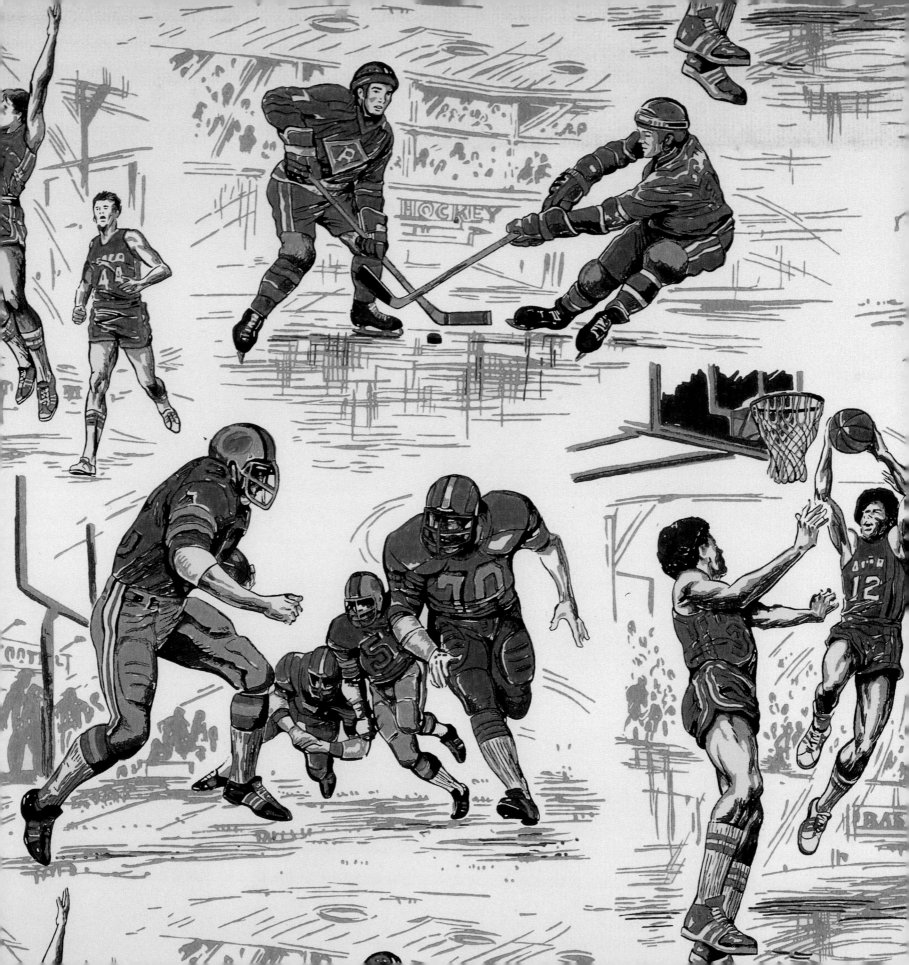

5 *Tall Tales*

NARRATIVE WALLPAPERS

Prompted by television programs such as *Bonanza* and *Rawhide* and by Roy Rogers' and Dale Evans' Hollywood films, Americans of the 1950s were partial to Wild West iconography.

If a picture is worth a thousand words, a figurative wallpaper is a veritable epic. Narrative wallpapers occupy a very distinctive niche in the repertoire of ornamental coverings. Among the earliest prototypes, the most popular in the heroic age of paper hangings—in the seventeenth and eighteenth centuries—were wallpaper designs that told stories. Well-loved and familiar tales based on classical myth, on Biblical accounts, and even on history had been the stock-in-trade of tapestries and oil paintings throughout the Renaissance. During the Enlightenment and the Industrial Age, they migrated to the walls of aristocratic and haute bourgeois palaces to provide theatrical backdrops for the routines and rituals of daily life.

Designed to intrigue, delight, and often to instruct, narrative wallpapers are by nature attention-grabbing, leaving no room for the competitive distraction of paintings or monumental furnishings. The best examples combined expanses of luminously painted skies with scrupulously rendered tableaux of nature, architecture, and human actors. Their designers—usually anonymous draftsmen and colorists working from life or copying from "high art" models—ingeniously arranged the narrative moments to follow each other sequentially around the room, using the spatial axis to represent temporal unfolding. The famous scenic wallpapers of the late eighteenth through mid-nineteenth centuries were composed as dioramas,

⬆ The daily life of "Gay Paree" takes center stage in this United Wallpaper design entitled "Café de la Paix."

⬤➤ Bursting with exuberance, sailors disport with señoritas on a nocturnal beach in this mass-produced American wallpaper.

whether landscape or historical in theme, that served as a continuous ground for narratively discontinuous scenes. The famous wallpaper on the theme of Ovid's *Metamorphoses*, dating from 1800, set the model for the combinatorial technique of scenic panoramas. This consisted of specifically designed transitional elements or separator lengths, usually depicting rocks or trees, which could be spliced in between the narrative episodes to provide continuity and, at the same time, to respond to the spatial exigencies of the specific interior they covered.

There were representations of famous historical battles—the "Bataille des Français en Italie," "Revolution de 1830," "Paysage napoléonien," "Bataille d'Essling," "Bataille d'Austerlitz," "Bataille d'Héliopolis," "Passage des détroits"—filled with the sound and the fury of battle set against majestic panoramas of natural and cultural landmarks. Some of these narratives focused on current events, functioning as reportage. Such, for instance, were papers that celebrated technological inventions, archeological finds, or architectural and urban advances. The apex of scenic artistry was found in the wallpapers based on episodes from the *Odyssey*, the *Aeneid*, and other classical legends and myths. These complex creations were Janus-faced: they looked back to the narrative murals of antiquity and the didactic frescoes of the Middle Ages; at the same time, they anticipated the narrative

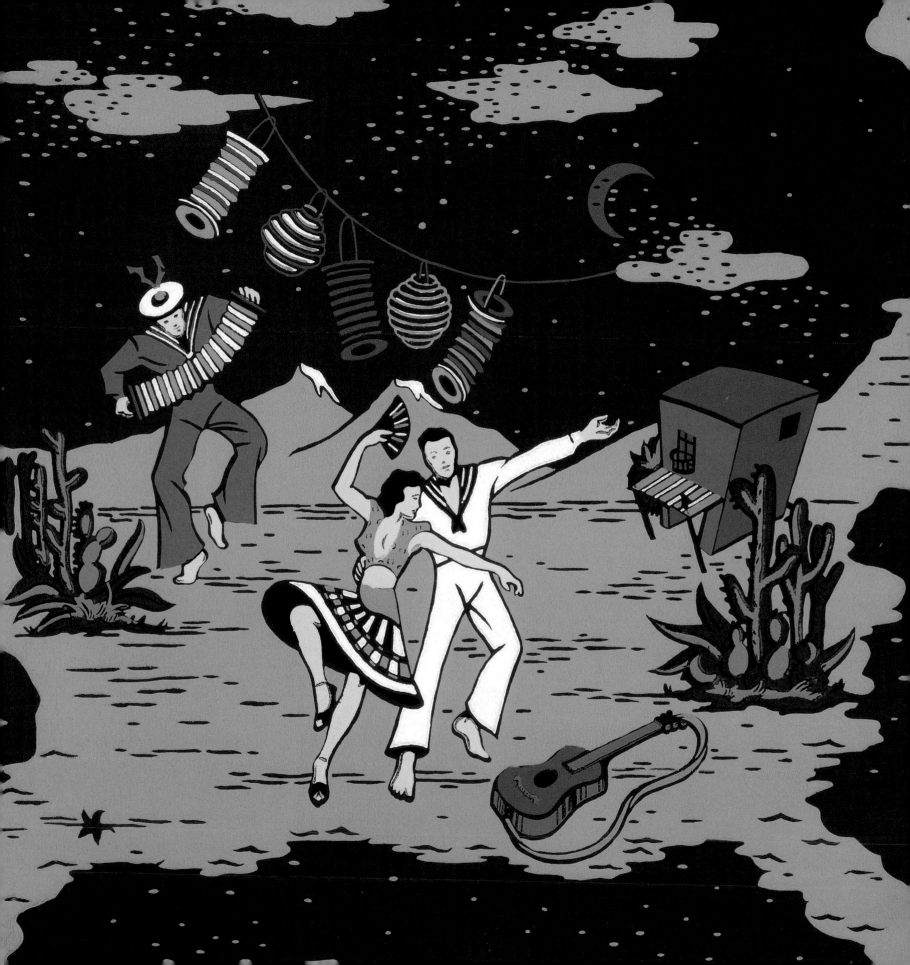

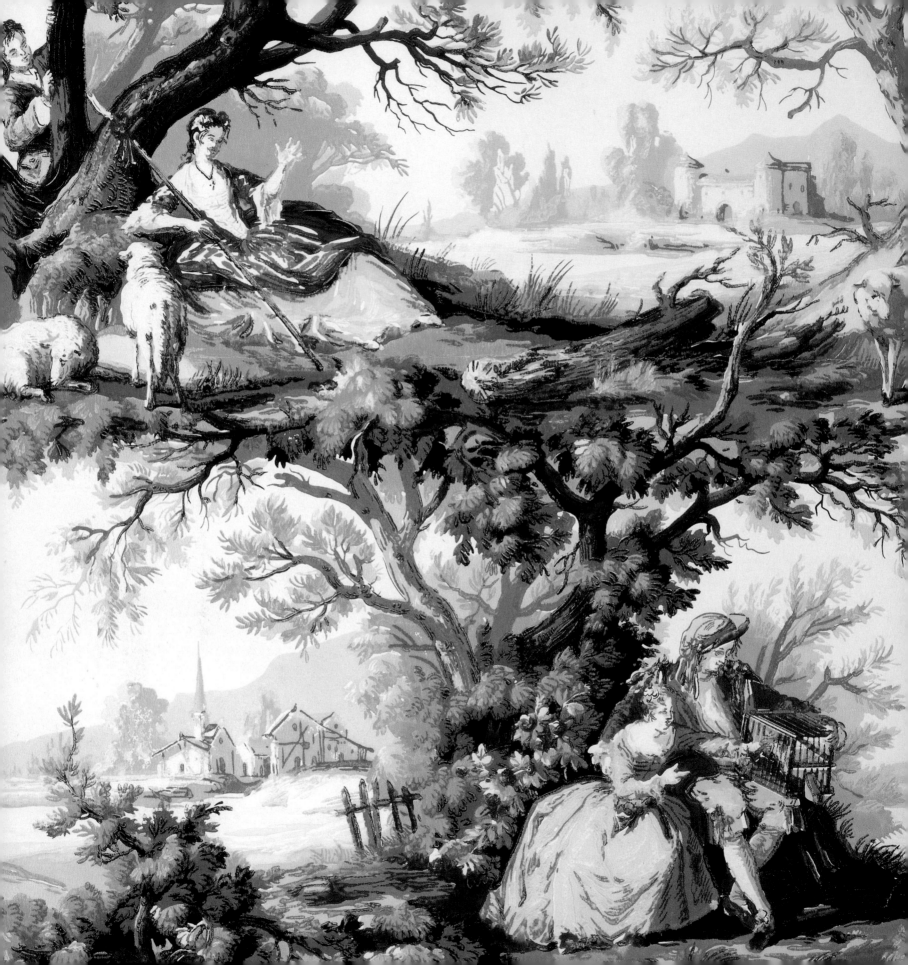

◄● The latticework of tree trunks and branches frames vignettes in the style of Antoine Watteau's amatory idylls in this British paper from 1945.

●► The key elements of the pastoral idyll are present in this stylized, machine-printed wallpaper from 1946. The deer and vegetation, representing wild nature, alternate with human figures evoking agricultural cultivation.

techniques of the cartoon strip. Some accompanied each scene with cartouches giving the names of the characters or indexing the literary source. Most of the time, however, the designers of narrative papers relied on their cultivated clients' familiarity with mythological, literary, and operatic texts: Bernardin de Saint Pierre's *Paul and Virginia*, Apuleius's *Amor and Psyche*, Sir Walter Scott's *The Lady of the Lake*, Torquato Tasso's *Orlando Furioso*, Rossini's *William Tell*, and Meyerbeer's *The Huguenots*. Among these highly erudite designs were various allegories based on contemporary paintings, such as the famous unfolding of the allegory of the stages of love based on Watteau's *Pilgrimage to the Island of Cythera*.

Very few scenic papers with the universalist ambition of the eighteenth and nineteenth centuries survived the modernist revolution. On a philosophical level, this was due in part to an intellectual disenchantment with narrative itself. More pragmatically, however, the vast interior spaces required by the scope of narrative papers were simply not available in twentieth-century urban and suburban housing. Here and there, nostalgic and traditional-minded manufacturers in Europe and in the United States occasionally issued reproductions of the ambitious nineteenth-century narratives. More often, they scaled down the demands of the genre to murals that told a story.

⬆ A commercial, 1950s Americana print depicts rural life.

⬇⬇ Arabesques frame repeating scenes of rural life in this twelve-color Atlas wallpaper.

➡ In the 1950s, Masterpiece Interiors produced a number of superb Americana-themed landscape wallpapers.

Among the very best contemporary analogues, dating from the 1930s and 1940s, are theatrical papers such as "King Christophe" by French scenic designer Nicholas de Molas, and "American Landscape" by Hungarian designer and illustrator Ilonka Karasz. A modern rendition of Napoleon's fleet calling at the citadel of the Haitian regent, de Molas's nine panels depict a tropical island rising out of an azure Caribbean in a series of gently rolling hills interspersed with palms, palaces, and ruins. In the foreground, among an assortment of whimsical animals, Haitian nobles and peasants interact with French sailors and dignitaries. By contrast, Karasz' 1948 rendition of rural America lacks plot. Rather, in the spirit of Grant Wood, it stages a timeless bucolic fantasy of a domesticated nature, replete with plump livestock, ripening fields, fishermen dangling lazy lines into a placid stream, and families feasting from a laden, red-checked tablecloth. Karasz does not aim for three-dimensional illusion, but maintains the two-dimensional integrity of her medium. Her valleys, hills, barns, fields, and paddocks re-create an agrarian Eden in an episodic treatment that proved seminal for mid-twentieth century scenic papers.

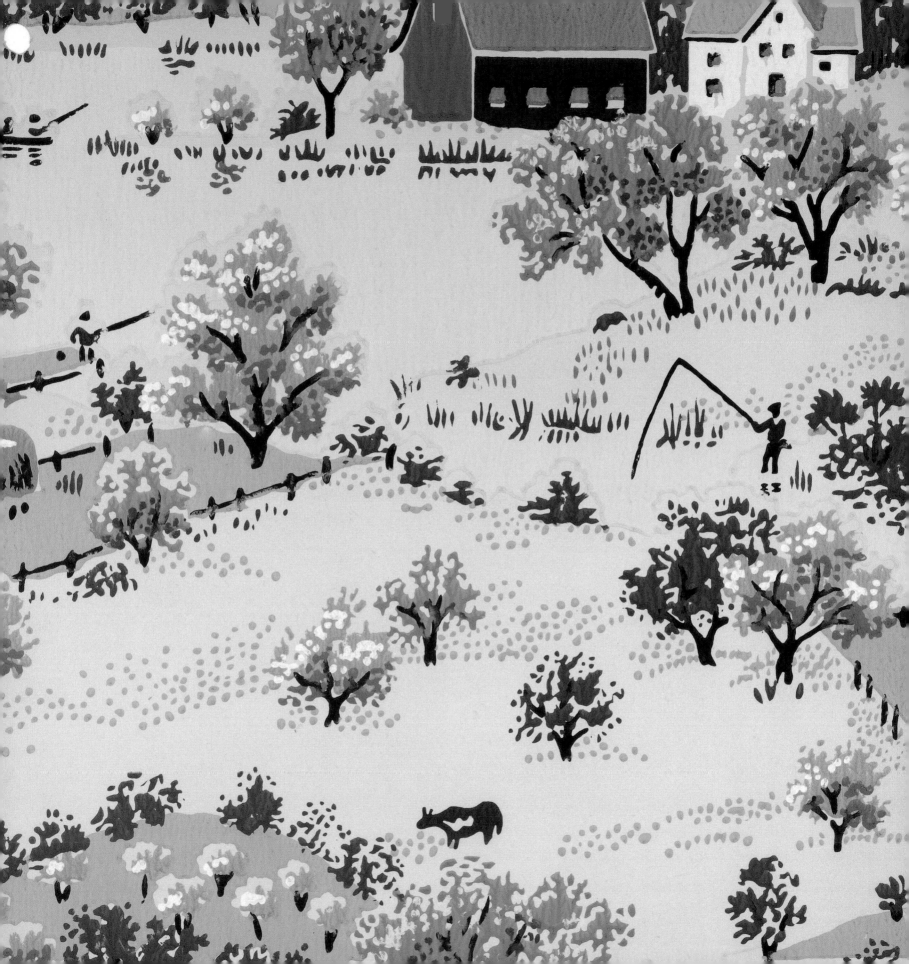

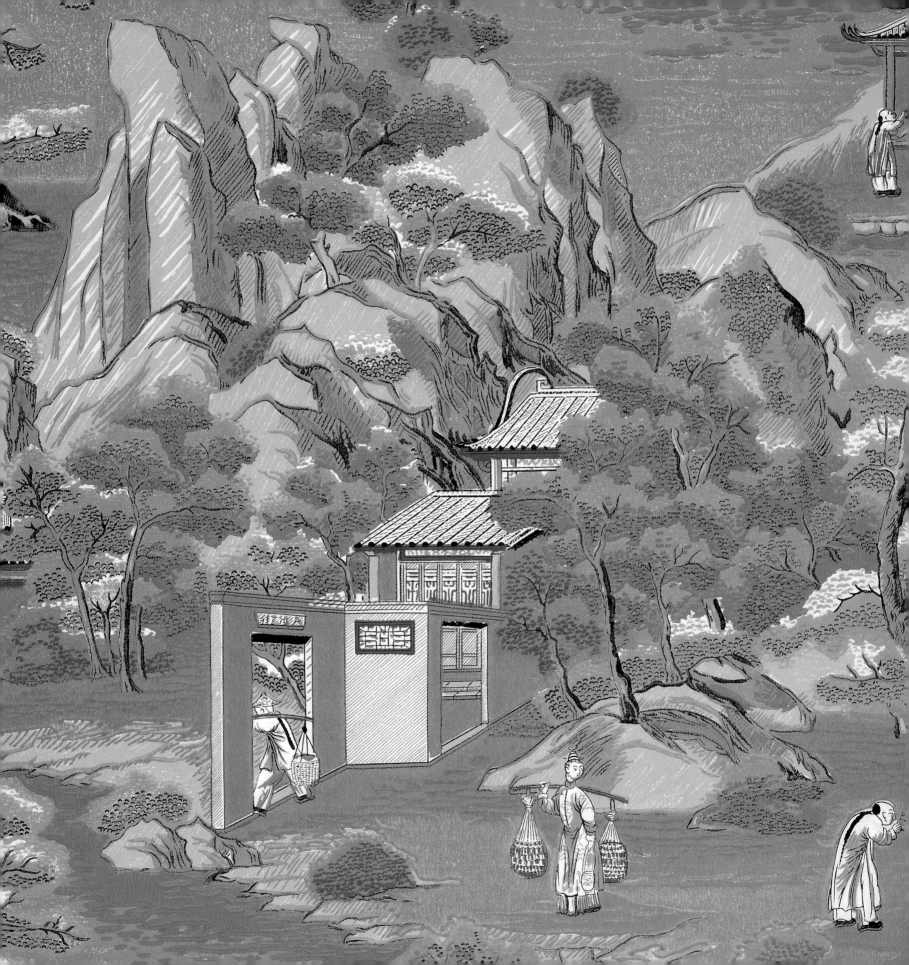

Instead of presenting a coherent visual narrative, most scenic papers from the 1940s through 1960s offered anecdotal vignettes of "genre scenes": representations of quotidian activities, holiday celebrations, or recreational pastimes. These run the gamut of images depicting city ladies strolling with dachshunds, housewives in sleek convertibles, waltzing couples, barbecues, cocktail parties, carnival thrills and spills, and lazy summer dreamers suspended in hammocks. Largely extinct at the moment, these genre scenes represent updated renditions of the spirit—if not the letter—of the *fête galante* hybridized with the "ethnographic" approach of Chinese scenic wallpapers. Two genres coalesce in these celebrations of middle-class domesticity, often with considerable, if naïve, charm. In a sense, when projected on the walls of a suburban home, these wallpapers serve as yardsticks by which the residents measure their resemblance to the prototypical, almost hagiographic, model of the ideal family paraded on their walls.

Related to these anecdotal wallpapers are designs that reduce the narrative content even further, distilling the situation or activity to a single object, motif, or figure in a "synecdochic" approach. These wallpapers evoke middle-class life through its emblems. To this end they recall the still-life paintings of game, flowers, books, musical instruments, comestibles, and crockery in which the seventeenth-century Dutch burghers celebrated the

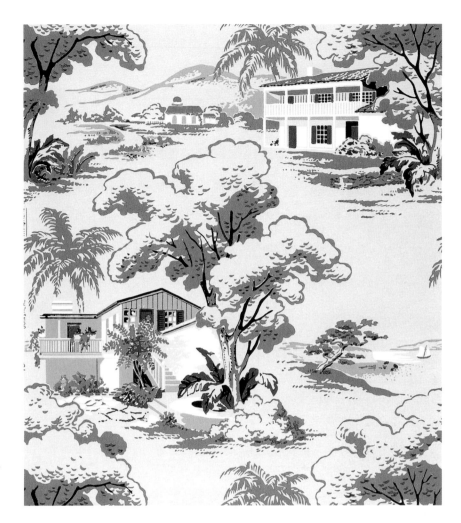

⚲ "California Villas," a machine-printed wallpaper from 1954, was produced by Griffin-Sefton, Inc.

◄● This superbly refined Chinoiserie wallpaper was created by Paul Dumas, one of the leading French designers in the 1910s and 1920s.

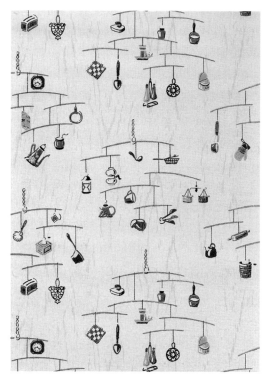

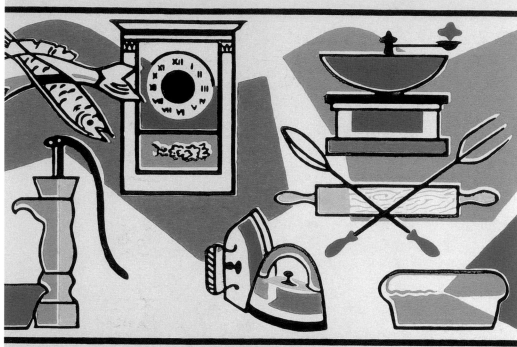

⬆ A faux-birch pattern serves as a background to this inexpensive, seven-color design of mobiles supporting kitsch kitchen utensils.

⬆⬆ The pre-electrified kitchen ornaments this 1940s frieze.

➡➤ This 1950 United Wallpaper design gathers together the conventional tools of female allure: perfume, mirror, ribbon, fan, rosebud, and lipstick.

poetry of everyday life. Largely intended for the overtly "functional" rooms of the house, such as kitchens, bathrooms, dressing rooms, and closets, wallpaper still-lifes feature kitchen utensils, bowls overflowing with ripe fruit, powder puffs, ribbons, hairpins, brushes, hats, and even—in a satirical German pattern from the early 1970s—dollar bills. In short, all the flotsam and jetsam on which our quotidian well-being depends envelops us in the two-dimensional panels of these wallpapers. ●

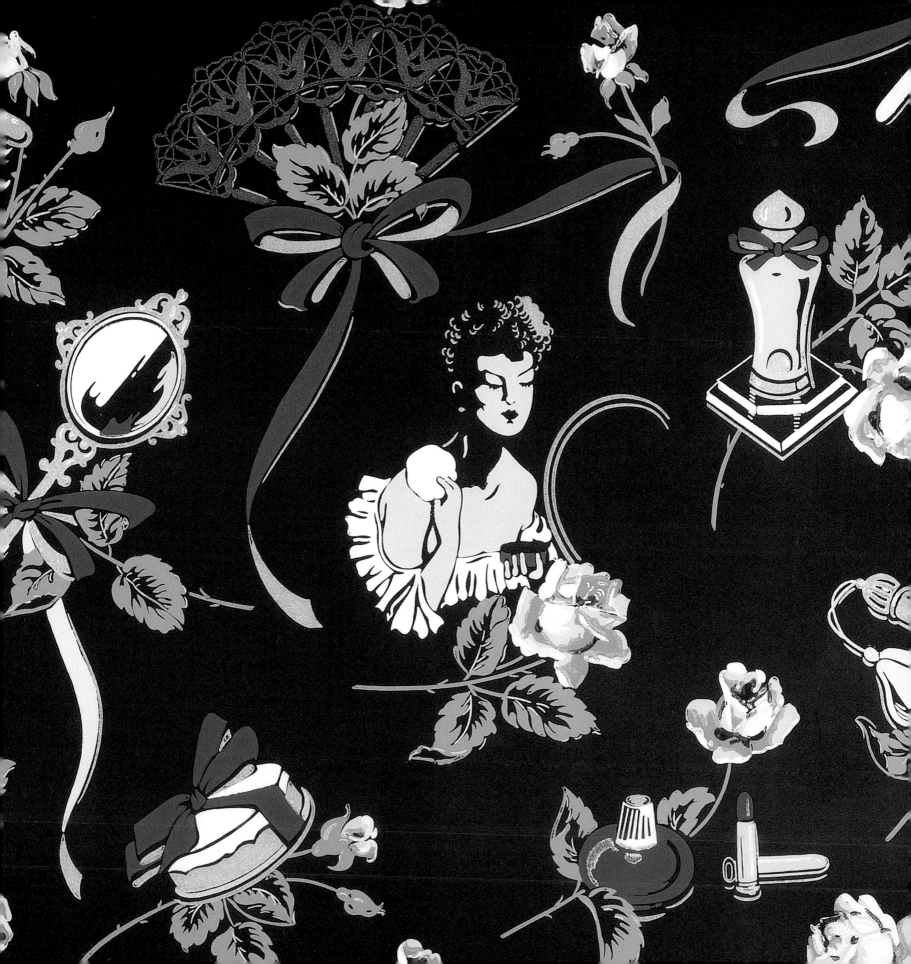

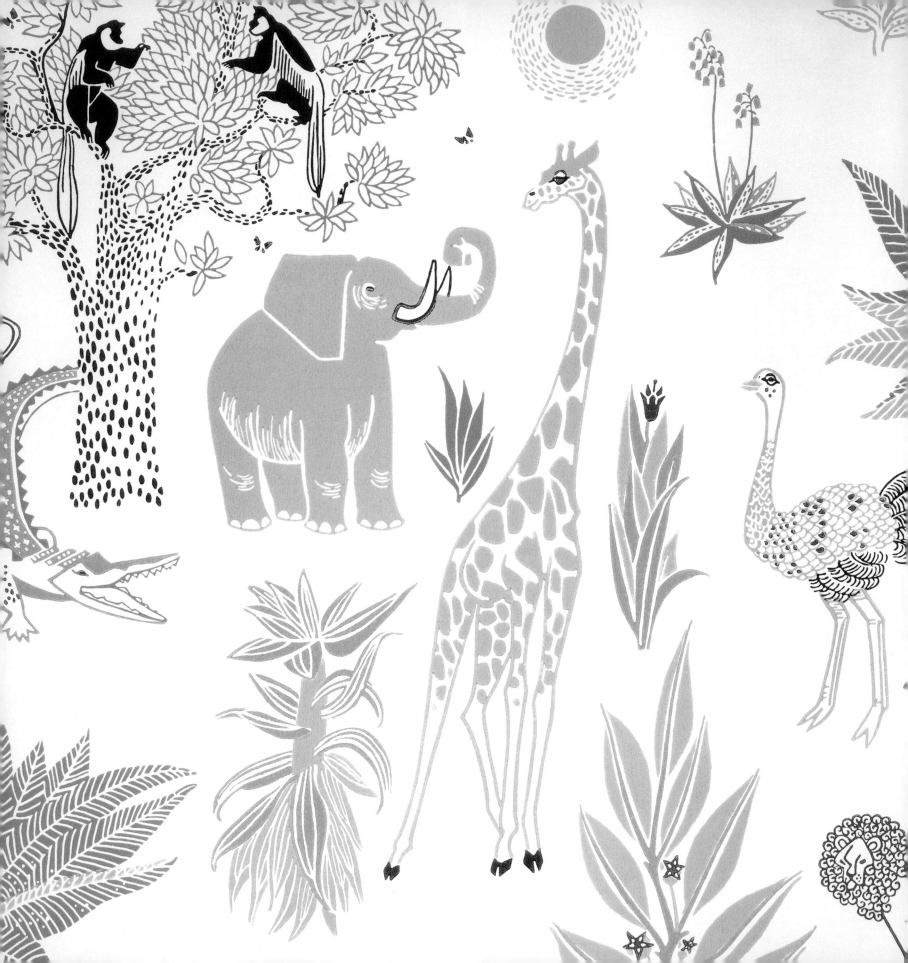

6 Noah's Ark

ANIMALS, CIVIL AND SAVAGE

This safari-goes-pastel was intended for a child's room.

From the earliest block prints of the eighteenth century with their crudely limned hounds and hares in full flight, animals have been an integral element in the design of scenic wallpapers. This was especially the case in those erudite nineteenth-century patterns that served as compendia of botanical, ethnographic, and zoological lore. Traditional visions of the garden of earthly delights were enriched by images of animal and insect species discovered in the course of colonialist expansion into remote corners of the globe. The monkey, the elephant, and the tiger had long been symbolic of a certain Oriental atmosphere. To these were added fantastical tropical birds, fearsome arctic bears, crocodiles, serpents, and simians, all generously endowed with imaginary features and hyperbolic attributes.

Parallel to these existed popular hunting and pastoral scenes, corresponding, respectively, to "hunter" and to "gatherer" cultural models. The former gloried in gory renditions of blood-crazed hounds ripping into the flesh of exhausted hinds, does, lions; "heroic" variants featured humans chasing after game and presented bounding horses trailing airborne foxes across landscapes of plump hills and pellucid streams. The "gatherer" variants focused on agricultural scenes, depicted in panoramic or in repeating designs. The rich nineteenth-century repertoire of pastoral papers elaborated on the imagery of Virgil's eclogues, with a liberal cast of adoring dogs, placid ewes, and grazing bovines

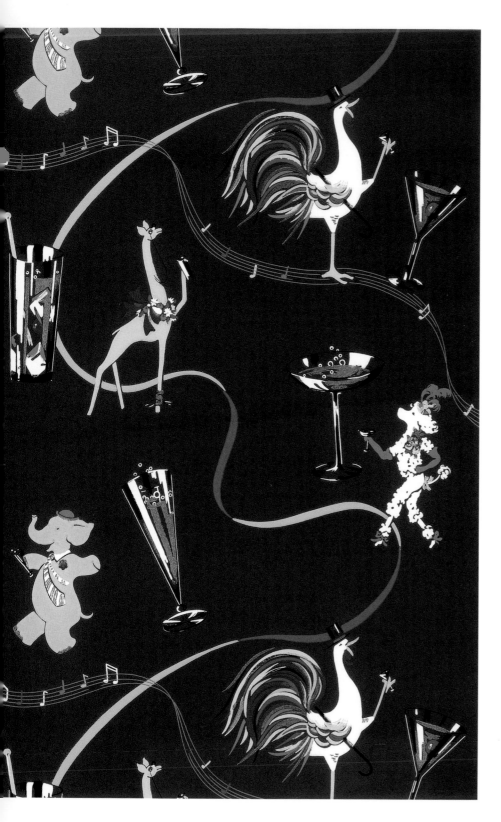

representing a return to a golden age. As "grace notes" in Romantic landscape designs, these domesticated animals stood in as icons of a "sense of benign nature" as predicated by Jean-Jacques Rousseau and as propagandized by writers and artists of a sentimental strain. Alternatively, the depictions of animals functioned as allegorical props, didactic cues to the moral lessons to be found in nature — of birds feeding their young, of gamboling lambs, and of deer in deepest familial harmony.

The three typologies of the exotic, the heroic, and the bucolic fundamentally set the scene for subsequent treatment. Later in the century, designers such as William Morris, Walter Crane, and Christopher Dresser worked animal images into floral designs, incorporating birds, fish, stags, butterflies, horses, and heraldic beasts into the pattern. In the 1880s and 1890s, the taste for Japanese-inspired designs brought a proliferation of

◄● Pink elephants, yellow giraffes, white poodles, and white roosters mingle with cocktail glasses in this 1952 United Wallpaper design.

●► This mass-produced paper from the 1950s evokes the Belle Époque by casting bunnies in the role of a hedonistic couple at the Follies Bergère, at the beach, and in the artist's atelier.

●►► The *Bambi*-inspired, cartoony treatment of garlanded deer made this wallpaper suitable for the room of a young girl.

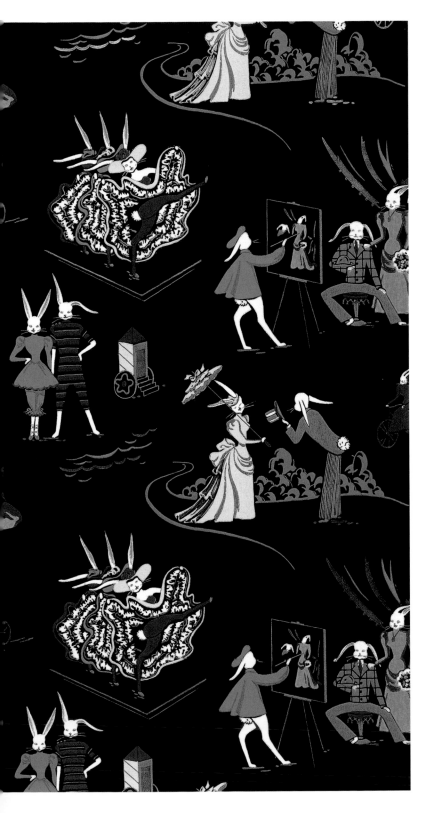

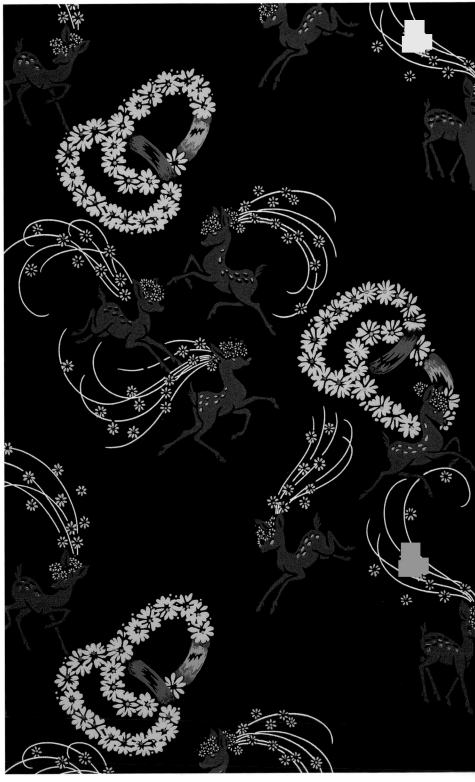

◄● "Aviary" was one of a number of designs by the Romanian-born artist Saul Steinberg for Piazza Prints of New York, a small, independent firm producing hand-screened papers after World War II.

●▶ John Rombola designed the witty "Cat and Canary" for Harben Papers, Inc., of New York in 1958.

sinuous birds—such as swans, cranes, peacocks, storks and fantastical winged dragons—into the art nouveau and Arts and Crafts repertoire. The ornamental Vienna-based secession style, originating in the Wiener Werkstätte in the first two decades of the twentieth century, and French art deco also adopted these bird species into their design lexicon, though rendering them in highly stylized, diagrammatic forms. Tropical fauna, such as monkeys, jaguars, tigers, and zebras, had a special appeal for art deco, in part because of their "exotic" connotation, in part because their naturally ornamental features harmonized so seamlessly with the repeating grounds of deco designs. Eccentrically hued birds such as pink flamingos, peacocks, and parrots met the craving for brilliant tints that was ignited by Léon Bakst's orientalist stage and costume designs for Sergei Diaghilev's Ballets Russes in 1909.

The impact of other "high" art trends was felt on animal design throughout the early modernist phase, either in the iconographic treatment of the forms or in

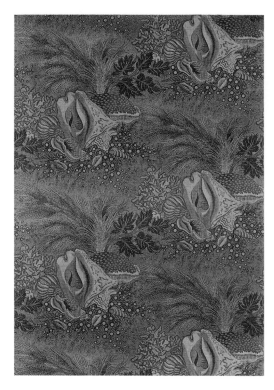

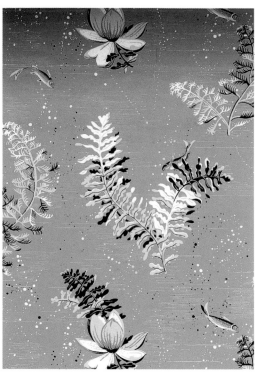

⬥ For the scuba phobic, this underwater wallpaper reproduces the natural treasures of the deep.

⬥⬥ United Wallpaper produced washable, fade-proof papers suitable for bathroom use such as this design featuring pink koi, water lilies, and sea grasses on a gray background.

⬤➤ The Eisenhart Wallpaper Company published this contemporary underwater design with an unusual net motif as the background.

the innovative use of line and color. Some of the designs were adaptations inspired by impressionism, cubism, and fauvism. Others were original designs contributed by fine artists. Two such examples from the 1920s and 1930s were provided on both sides of the Atlantic. In England, the calligrapher and illustrator Edward Bawden designed delightful, surreal figurative wallpapers such as "Desert and Camels" and "Wood-pigeon." In the United States the American painter Charles Burchfield produced startlingly original scenic papers, such as "Robins and Crocuses" and "Blue Birds and Cotton Woods" that showcased indigenous bird species in their native habitats. At the same time the Parisian couturier-cum-interior designer Paul Poiret reinterpreted such hackneyed themes as doves and roses, seashells and lilacs, for a line of wallpapers, some of which were used in staterooms in the luxury liner *Ile-de-France*. Until the 1950s, animals figured in wallpaper designs largely as stylized ornamental figures, as in the case of Marian Dorn's and Marianne Mahler's abstract birds in flight patterns, Vicke Lindstrand's cartoony safari prints, or Marie Gudme Leth's garden animal prints with engaging garter snakes, frogs, and snails.

After World War I, a zany playfulness infected standard animal imagery. Under the influence of animated cartoons and advertising mascots, the line separating the inanimate world of objects from the animate world of humans and animals became permeable. Suddenly, a new universe of images lumped under the general heading "novelties" appeared on the market. Wittily conceived figurative designs and semi-

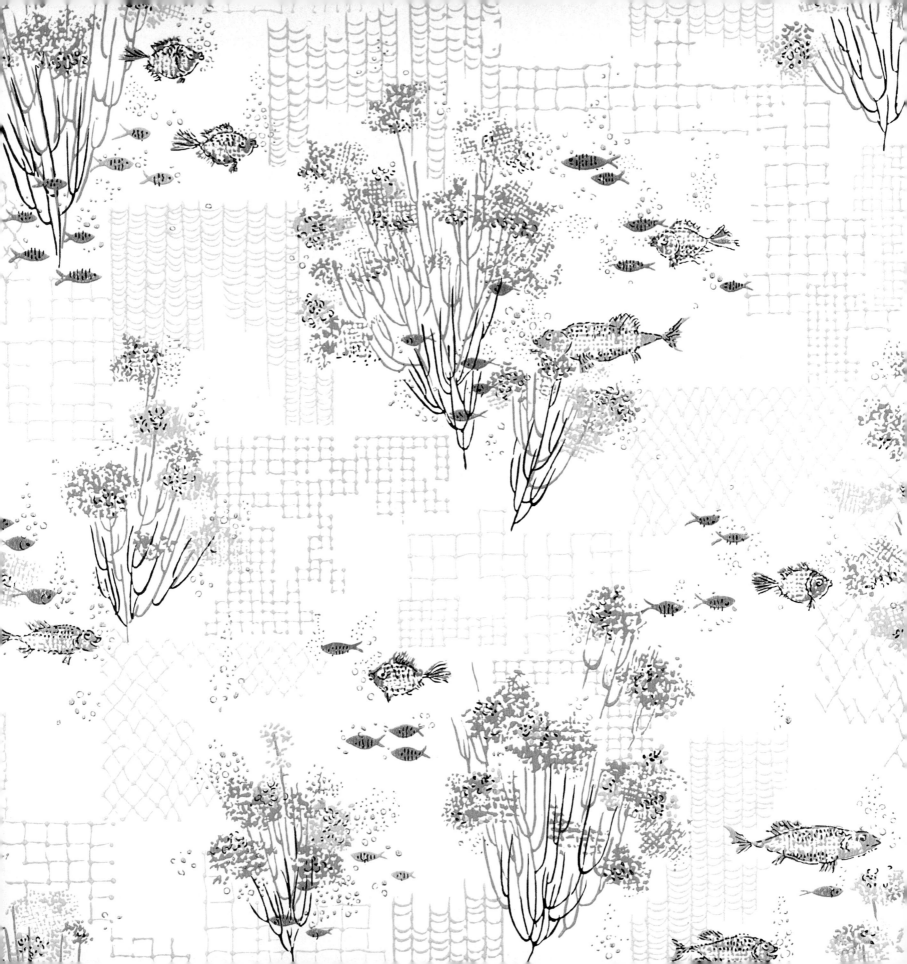

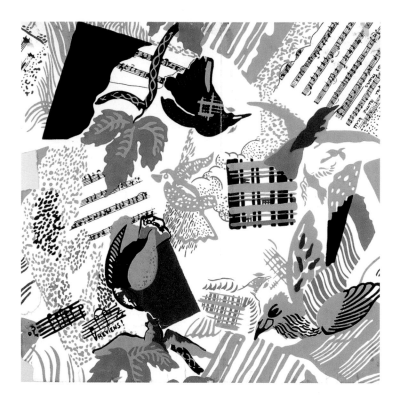

⬇ The lyrics beneath the musical notes of Jean Lurçat's 1924 wallpaper read, *Celui qui aime ecrit sur les murs* ("One who loves writes on the walls") and *Reviens!* ("Return!").

➤➤ A barnyard scene for the kitchen projects members of a poultry nuclear family against a ground of scattered grain.

representational patterns of inanimate objects, novelties made their debuts in the mid-twenties as alternatives to the more conventional categories of florals, geometrics, and figures. Amusing and fun, novelties brought the exuberant vitality of the carnival, the amusement park, and advertising into the home. As an alternative to florals and polka dots, novelty patterns reflected the modern American scene and temperament.

Nothing was considered too humble or too humdrum to escape enshrinement on domestic walls. Buttons, thread, sugar lumps, mothballs, and thumbtacks spilled across boldly colored backgrounds, each mundane object accompanied by a reassuring shadow. Many of these objects metamorphosed into fantastic creatures: fruit and vegetables sprouted human faces and limbs. Bottles, cans, forks, and dishes waltzed across kitchen walls on spindly legs, even as dice and playing cards took on the personalities and facial tics of gamblers. These animated phantasmagorias paralleled the charm and power of Disney's *Fantasia*. ●

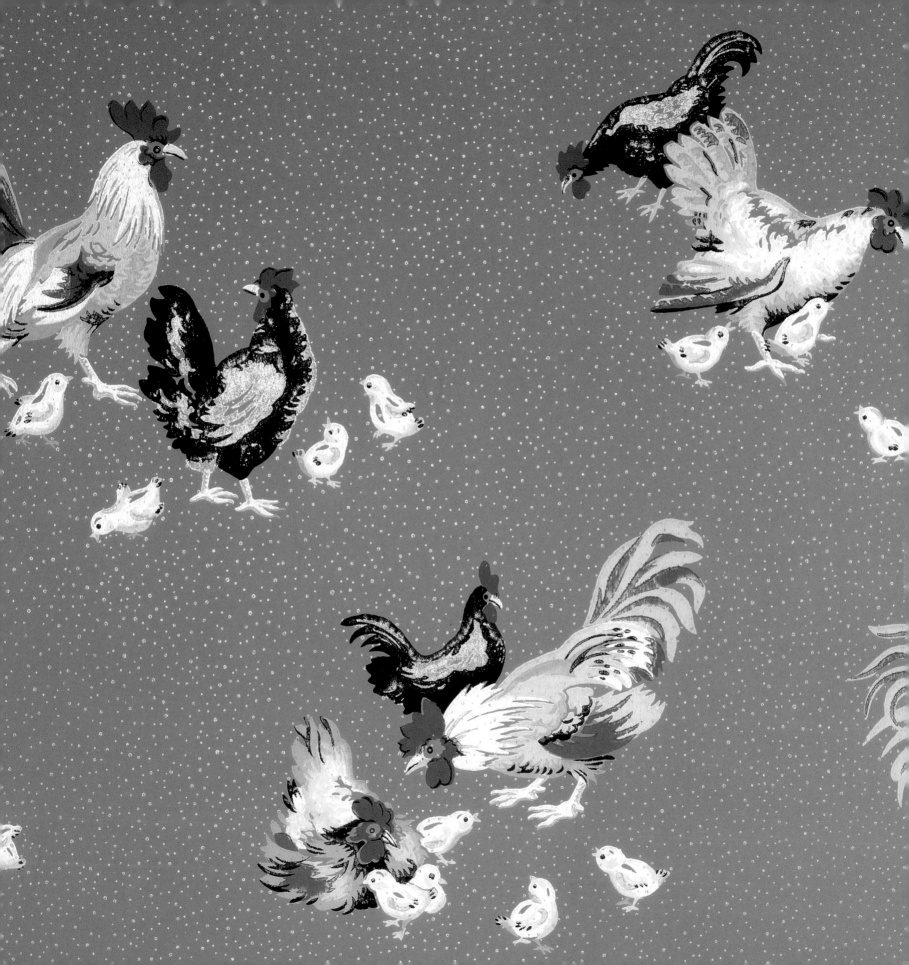

7 A Yen to Travel
EXOTICA, PEOPLE, PLACES, AND THINGS

John Rombola designed "Bullfight" for Harben Papers of New York.

Among the varieties of wall coverings, none are as conducive to dreaming and reverie as the class devoted to travel. Surrounded by images of distant landscapes and remote times, one can let the eye and mind wander at will while the body remains blissfully untaxed by the rigors and anxieties of travel. At the center of a private microcosm, making a theater of one's dwelling, the armchair traveler can gratify a desire for exploration and bask in the sensation of being connected to the universe. Such, at least, is the ideal condition of travel-themed wallpapers as conceived and elaborated in the eighteenth and nineteenth centuries. In an oft-quoted explanatory pamphlet accompanying the ambitious scenic wallpaper "The Savages of the Pacific Ocean," the manufacturer explicates this imperative: "We thought we would be appreciated for having assembled, in a convenient and visible manner, this multitude of peoples separated from us by the vastness of oceans, in such a way that, without leaving his apartment but just casting his gaze around him, the armchair traveler who reads the general history of voyagers will believe himself in the presence of the characters, will compare text with painting, will become fond of peculiarities in figures and dress, will appreciate the skill of some and the tastes of others, and will follow the details of the account with an interest all the greater for seeing them in relief, if one might use that expression, and in all the splendor of the freshness and choice of colors."

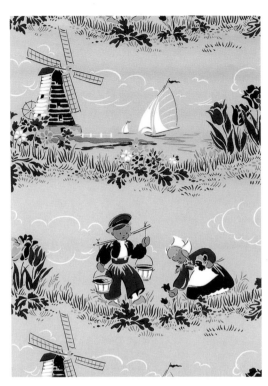

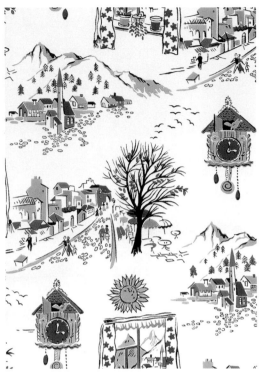

⬧ "Going Dutch" in this Enterprise Wallpaper from the 1950s juxtaposes landcape and narrative motifs.

⬧⬧ This J. C. Eisenhart Wallpaper Company design rehearses picture-postcard icons of the Swiss countryside.

➤ A scattering of playful motifs evokes the exotic spell of *The Arabian Nights* in this characteristically vibrant French paper from the 1930s.

Gérard Mabille, the French historian of design, tells how Parisian grandees of the late eighteenth century indulged their seemingly insatiable appetite for exotic and natural locales with a novel form of décor in which painted papers conspired with interior appointments to banish architecture; dissolve walls, ceilings, and floors; and create a seamless illusion of unbounded space. Decorative ensembles for aristocratic pleasure houses in the environs of Paris achieved their fictional effects by aiming for a total re-creation of another reality. The paper walls evoking gardens and woodlands were painted with trees whose tops grazed ceilings of imitation skies and whose trunks disappeared into floors covered in real or imitation grass. Sharp corners of walls and cornices vanished beneath rounded forms. Furnishings were fashioned from tree trunks, and paths snaked around them in seemingly random patterns. Such were the demands for illusionistic effects that every effort was made to break the tyranny of the architectural enclosure, and to transform the static home into a dynamic theater of the imagination by projecting an "other place" onto the surface of one's own walls.

At their heyday in the eighteenth century, scenic wallpapers fulfilled a number of cultural agendas. Lessons in geography and self-celebratory memorials at once, they satisfied the new intellectual fashion for nature and for the "natural" as packaged by Jean-Jacques Rousseau. His was a nostalgic myth of the "man of nature" that embodied an Edenic perfection in a time and place—be it classical antiquity or the South Pacific of Louis-Antoine de Bougainville—remote from the corrupting influence of civilization

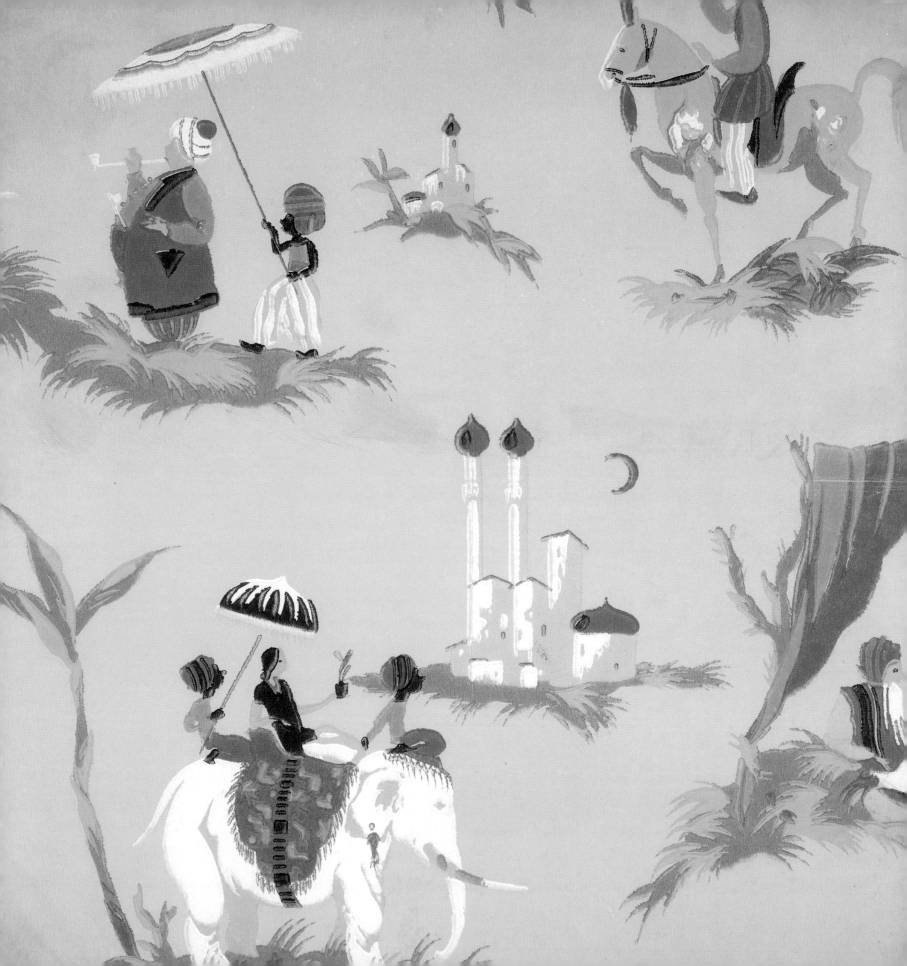

and its discontents. Surrounded by the trompe l'oeil décor of scenic wallpaper, the resident was also drawn seamlessly and effortlessly into a pedagogical endeavor, expanding his knowledge of the world. Such, in fact, was often the avowed objective of the papers' manufacturers. Joseph Dufour, in the promotional brochure accompanying "The Savages of the Pacific Ocean," makes the didactic role of his product explicit. "A mother will give, without noticing the effort, history and geography lessons to her lively, intelligent, questioning little daughter." In papers such as the vast landscape panoramas of China, Brazil, India, the Near East, Egypt, and North America, the exotic was brought home in brilliant color and scrupulously observed detail. The European craving for "Oriental" motifs and images found expression both in extended, panoramic vistas and in patterned medallions of discrete scenes from the "exotic." As a result, pleasure and utility were combined in these "utopian" spaces that thrust the observer into an unprecedented and totally fantastic role: of being simultaneously traveling and stationary, observer and protagonist, at home and abroad.

As a by-product of the cultural institution of the Grand Tour, that obligatory geo-cultural rite of passage for gentlemen and ladies, scenic wallpapers were produced as monumental picture postcards, serving as tangible re-creations of ephemeral experiences. The practice of the Grand Tour functioned as an immense treasure trove of images, associations, and memories that were both personal and collective. Usually based on engravings or paintings, these wallpapers depicted recognizable sites on the obligatory itinerary that extended from Scheveningen in Holland, through the Alps, and along a string of picturesque ruins on the Italian peninsula.

As new travel routes were added to the repertoire of fashionable excursions, wallpapers brought their distinctive sights to the home. The Sentimentalist tour of the Nordic wilds, the Romantic exploration of savage shores, the amateur scientist's birding and botanical

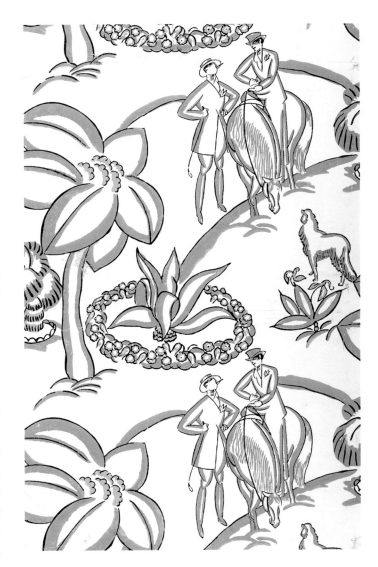

Agaves and palms provide a gracious setting for this superb scenic wallpaper from the late 1920s.

Jean-Emile Laboureur, one of the finest graphic artists of the Art Deco period, designed "Le Marin" ("The Sailor"), 1912–20.

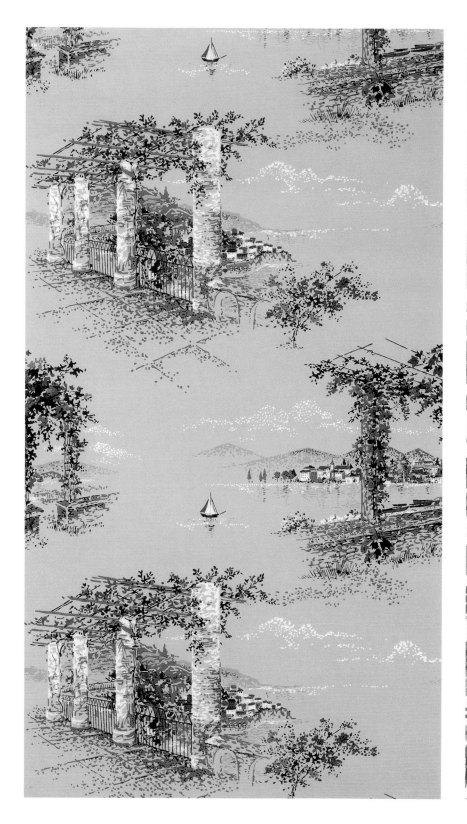

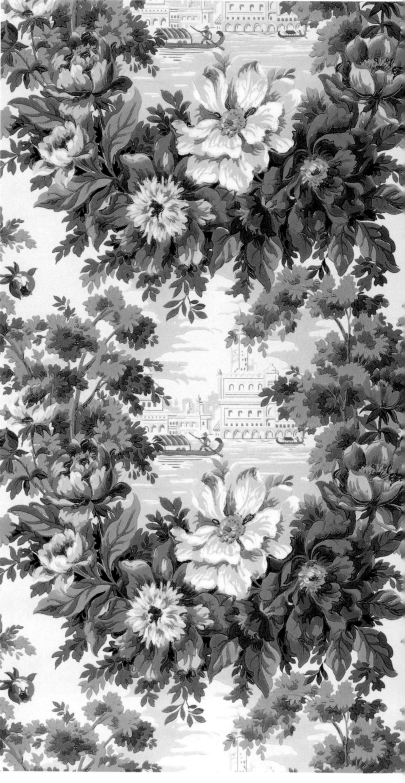

expeditions: all found their reflection in distinctive wall-paper designs. In this sense, panoramic wallpapers anticipated the cinemascopic travel films of the twenti-eth century. Filled with ethnographic, botanical, and archeological detail and packed with local color, these wallpapers invited the cultivated observer to survey the crowning achievements of nature and of human toil and ingenuity.

Finally, as the highest attainments in the genre of decorative wallpapers, the scenics were intimately linked with contemporary currents in fine arts, litera-ture, and philosophy. The fashion for papers depicting exotic locales, "noble savages," and awe-inspiring land-scapes stemmed from the Romantic sensibility. So, for instance, the Romantic addiction to the extreme sensa-tions triggered by "sublime" landscapes—such as colos-sal waterfalls, vertiginous peaks, and crashing ocean waves—made its way into wallpaper designs. In much the same way, the adrenalin rush of "extreme sports" can be vicariously appreciated in the virtual setting of surround-sound and the diode screen in the late-twentieth-century living room.

◄◄● Printed on a grass-textured ground, this tasteful wallpaper from the 1960s is one of a series celebrating European resort cities.

◄● Floral frames surround vignettes of Venice.

●► This Canadian-made wallpaper modern-izes the perennially popular chinoiseries motif of the oriental beauty in the garden.

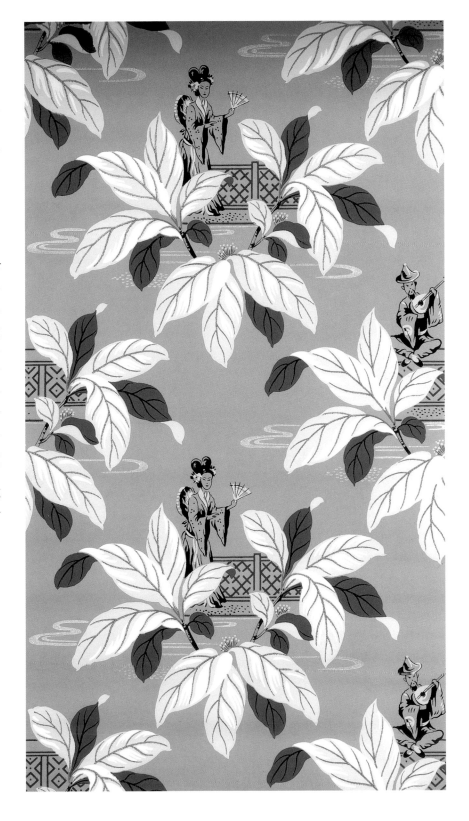

Schumacher's "Bon Voyage" exploits the escapist appeal of luggage labels.

Travel wallpapers took off in the immediate after-math of World War II when Americans, brought out of two decades of Depression-induced isolationism by their involvement in global warfare, took up tourism, both at home and abroad. Their excursions led them to the Rockies, California, the Gulf Coast, to amusement parks from Coney Island to Long Beach, and, abroad, to Mexico, Canada, the Bahamas, and all the European cities on the Grand Tour circuit. This newly found mobility left its mark on wallpapers-as-picture-postcards. To the repertoire of standard tourist views were added whole new classes of cultural icons, some inspired by contemporary films, some by television and popular magazine photography. Murals produced by James Seeman of New York and Albert Van Luit of Los Angeles depicted a broad spectrum of images, from urban skylines to views of Route 66.

In Germany the fashion-forward "Künstler Tapeten" line by the manufacturer Gebrüder Rasch offered finely delineated, quasi-cartoon cityscapes with recognizable landmarks: the Eiffel Tower, Arc de Triomphe, and Notre Dame exemplifying Paris, for instance. On the whole, however, the tendency to iden-tify place by easy-to-read souvenir iconography resulted in wallpapers overrun with "shorthand" images: hour-glass-figured mademoiselles, beret-clad bohemians, tight-trousered toreadors plunging lances into charging bulls, hombres sleeping under sombreros, natives scrambling up palm trees. By the end of the 1950s, the walls of Middle American "family rooms" were rife with politically incorrect stereotypes.

When, by the mid-1960s, the new youth culture rose to prominence, the most potent inspiration for new travel iconography became the acid trip. Actual geogra-phy ceded prominence to the hallucinatory topography of swirling lines, brilliant colors, and the biomorphic shapes of Peter Max, Hapshash and the Coloured Coat, and Wes Wilson. Such extreme visual stimulation could not go on for long. Indeed, after the synapse-busting mega-wattage of acid-inspired wallpapers, nothing could satisfy as much as nothing. According to the time-less dialectic of change, the only logical segue to the excesses of the Woodstock period in wallpaper art was the absolute negation of ornament, which led to the almost total triumph of the "less-is-more" aesthetic of the founding modernists: the return of the unadorned, austere white wall. ●

French Line
PIER 88 NORTH RIVER
NEW YORK

COMPAGNIE GENERALE TRANSATLANTIQUE
NEW YORK LONDON PARIS

AMERICAN
AIRLINES
AA

GRACE LINE

PASSENGER
PASAJERO

S.S.

SAILING STATEROOM
SALE CAMAROTE

DESTINATION
DESTINO

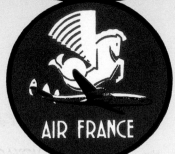

NORTHEAST
AIRLINES

PA

ITALIAN LINE ITALIA
 SOC. DI NAV. GENOVA

CABINA
CABIN No
1

SIG.
MR.

NAVE
SHIP

DA
FROM

DATA
DATE

PORTO DI SBARCO
LANDING PORT

Please show this
envelope to your hostess when
boarding your
TWA flight

AIR FRANCE

PAN AMERICAN WORLD

Matson Lines

PLEASE PRINT NAME STATEROOM

TO
HONOLULU
★
STATEROOM

A NEW AND ACCVRAT MAP OF THE WORLD Drawne according to the best and Late Discoueries Anno Dom 167

Sᵣ Francis Drake
Mᵣ Thomas Candish

NEW YORK
TO
BERMUDA
FURNESS
(PLEASE FILL IN INITIAL LETTER OF LAST NAME)

BERMUDA LINE

SAILING FROM
FURNESS TERMINAL
PIERS 95-97, NORTH RIVER
FOOT WEST 55-57th STREETS
NEW YORK

MOORE-McCORMACK
Lines

ST CLASS

NORTHWEST

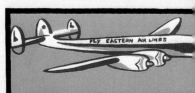

FLY EASTERN AIRLINES

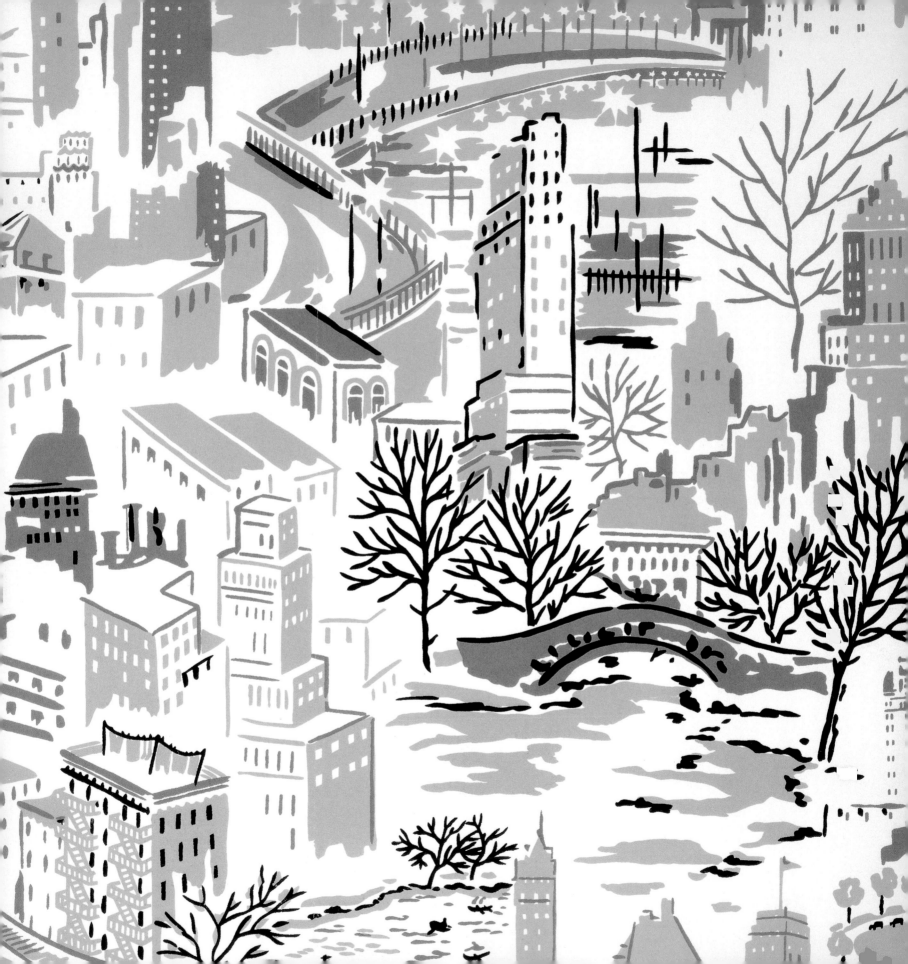

8 *The Great Outdoors*

BEACH, MOUNTAIN, FOREST, GLADE, GLEN, DESERT, WATERFALL, METROPOLIS

A cityscape provides the inspiration for this 1950s American wallpaper.

One of the great paradoxes at the heart of scenic wallpapers is the conceit of the indoors as outdoors. Visions of lush gardens or the wilderness provide an ephemeral escape from the depths of the modern metropolis. The inventory of landscape re-creations embraces everything from full-scale, photographic reproductions of land or seascapes to stylized scatterings of miniature vignettes depicting idyllic glimpses into pastoral realms. Like so many of our affective preferences, this taste is rooted in Romanticism with its discovery—or more precisely, "invention"—of nature as a kindred element imbued with ethical value and deep restorative powers.

While in the eighteenth century, the itinerary of the Grand Tour centered on cultural monuments, such as antique ruins or contemporary technological marvels, in the nineteenth century the focus shifted to natural wonders, such as waterfalls, glaciers, mountains, and seashores. Touring itself came to involve a greater degree of calculated physical exertion. Much like the eco-tourists of today, adventurous nineteenth-century travelers sought out challenging physical terrain in which to test their mettle. As Edward Whymper, the great British Alpinist confessed, "Toil he must who goes mountaineering; but out of the toil comes strength (not merely muscular energy—more than that), an awakening of all the faculties; and from the strength arises pleasure."

The landscapes of ordeal included spectacular panoramas of Niagara Falls, of volcanic eruptions, mountain ranges of the Americas, and storms at sea. A notable example of this genre is "Vues d'Amerique du Nord" (Views of North America), a monumental set introduced in 1834 by Zuber et Cie. This spectacular design surveys the preeminent tourist destinations of the United States, with most of the sites strung along the Hudson River as a connecting thread. The pattern, installed by Jacqueline Kennedy in the White House in the early 1960s, is still printed to this day.

In addition to full-blown panoramic scenarios, wallpaper manufacturers also produced less ambitious, less expensive patterns. These designs, called landscape figures, featured small vignettes of exotic people, uninhabited wilderness, pastoral tableaux, and classical scenes, often contained within an embracing foliage motif or more formal framing devices, that alternated with related or contrasting vignettes. Many of these vignettes were based on famous paintings or drawn from the large scenic papers. As photography, photogravure, and electrotyping became commercially viable, the technology began to migrate into wallpaper design. Popular magazines were a rich source of the new imagery; by the end of the nineteenth century, there were at least three thousand periodicals, including the lavishly illustrated *Ladies' Home Companion*, *Scribners*, and *Harpers* and *Leslie's*. The new populist imagery remained true to the genre, concentrating the ethos of a place within a pithy, easily readable symbolic image, such as the cowboy riding on the range, the camel-mounted Arab in a desert, and the mountaineer waving from a peak. This is the reduced form in which the scenic landscape wallpaper has most commonly passed into the twentieth century.

As a counterpoint to these landscapes of ordeal, there were also landscapes of pleasure. The beach as a site of hedonism; the waterfall as a romantic trysting site; the meadow as the stage for sybaritic indulgence—these motifs retained an enduring charm. For the last two hundred years, the theme of the *fête galante*—representing an aristocratic group engaged in musical, theatrical, and amatory diversions in a natural setting—has been a staple of wallpaper design. Launched by the French rococo artist Jean-Antoine Watteau, the *fête galante* evokes a largely fictional world of adult play in a benign, bucolic landscape. This thematic complex enjoyed a particularly robust resurgence immediately after World War II, especially in the United States. Most recently the subject has been widely reproduced in the monochromatic style of "toile" textiles, in red, blue, or dark gray on cream. While most renditions of this theme retain the period costumes of their prototype, contemporary translations have appeared. In these parklike settings, the presence of ruminants such as sheep and cows, and of well-dressed humans at leisure, link the pattern to its eighteenth-century antecedents.

A subset of this general theme is the garden, usually, though not always, unpeopled. The rich cultural symbolism of the garden-as-refuge resonates with biblical and classical associations of sensory delectation, sensuality, fecundity, and control. Not surprisingly, of all the varieties of outdoor scenes, none has enjoyed more continuous and perennial popularity. As aesthetically manipulated landscape—in opposition to the utilitarian agrarian field—the garden is the locus of perfect

The orange ground in this stylized landscape of hills with trees is typical of French wallpapers from the 1920s.

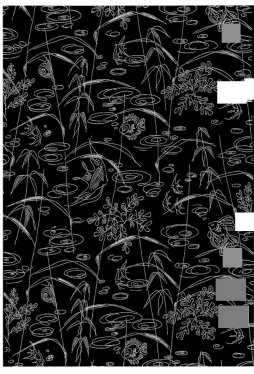

illusion, the point where nature and the human ambition to re-create the world in our own image coalesce. As the historian Pierre Grimal observed with reference to Roman antiquity, "The garden gave the house a dual landscape: interior and exterior. Both, however, are equally *symbolic*, equally unreal. Both are simply pretexts for more or less complex plays of the imagination in which the plants and flowers cease being solely themselves in order to serve a fiction." Simply put, the botanical and topographical contrivances of the garden conspire to form a "microcosm": a miniature synopsis of the world, a summary of our knowledge, and a repository of sensory experiences and memories.

Guided by contemporary theories of garden design, wallpapers have consistently replicated whatever happened to be the cultural ideal of the garden at a particular historical moment. Illusionist papers have wrapped the interiors of rooms in the perspectival order and axial symmetry of classical French parks. Others have reproduced the beguiling chaos of British "picturesque" gardens with belvederes, observatories, towers, and gazebos tucked into tangles of lush foliage. In America between World Wars I and II, traditional garden wallpapers continued to dominate the residential market. By and large, Americans tended to be interested in traditional, naturalist designs that depicted an idealized, unpeopled, and hospitable landscape. After the war, their commitment to bringing the outdoors indoors grew even stronger.

In the postwar building boom, builders and designers explored new ways of

⬦ A variety of corals and seashells defines this tropic underwater-scape.

⬦⬦ This 1956 design of sea grasses and angelfish was manufactured in Germany.

◂● In the 1910s and 1920s Parisian department stores got into the business of home décor, producing textiles and wallpapers in a range of eclectic styles, such as this striking marine pattern.

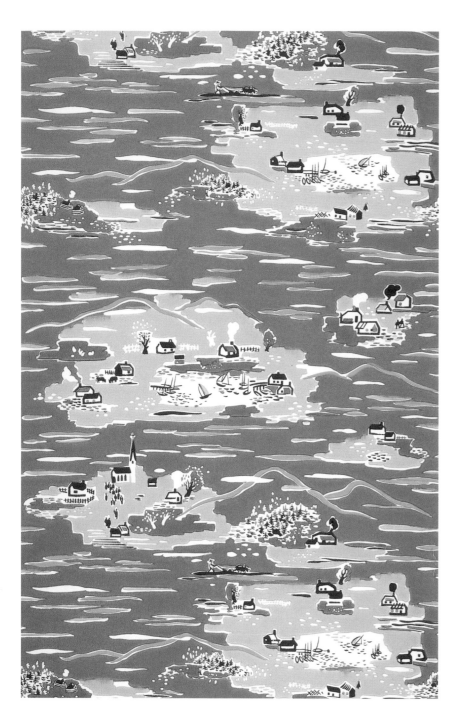

◄● Scenes of rural American life are vignetted in gray against a soothing green ground in this wallpaper from the late 1950s.

●► Among the best of the naïve style wallpapers of the 1950s were those, such as this Masterpiece Interiors example, inspired by Hungarian-born designer Ilonka Karasz.

opening up the house and bringing air, light, and unimpeded movement into the home. The open-plan suburban ranch house—airy, equipped with vast expanses of glass, patios, and skylights—was the result. The new residential idiom included differential treatment of walls. No longer was it obligatory to handle all walls as a single surface. For one thing, many of the interior partitions were done away with. For another, a variety of finishing surfaces was not only permitted but encouraged. The walls in a single home sported a veritable encyclopedia of surfaces: brick, concrete block, wood paneling, wallpapers imitating natural textures, and the twentieth-century version of the panoramic paper—an expansive photomural to fill a single wall and give the illusion of a natural vista. Available in black-and-white and in full color, photomurals of beautiful wild vistas by the likes of Margaret Bourke-White, Edward Steichen, and Ansel Adams did double duty as art works and illusory picture windows. One such paper, "Jackson Lake"

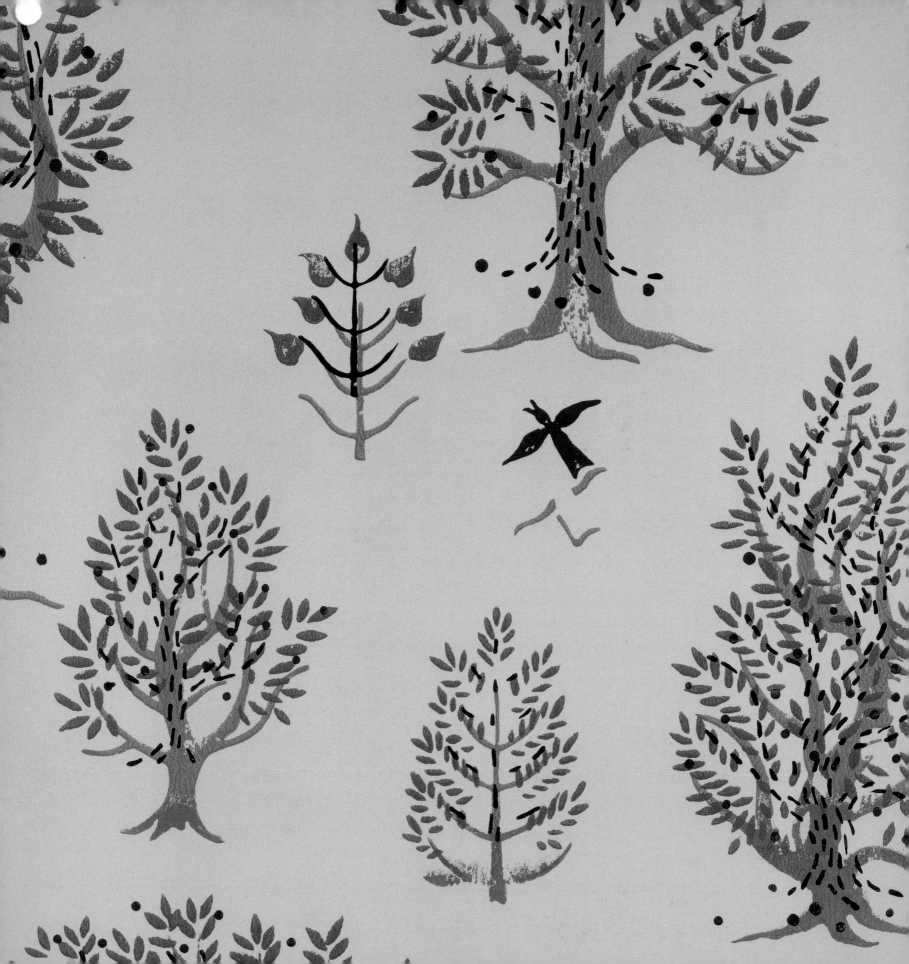

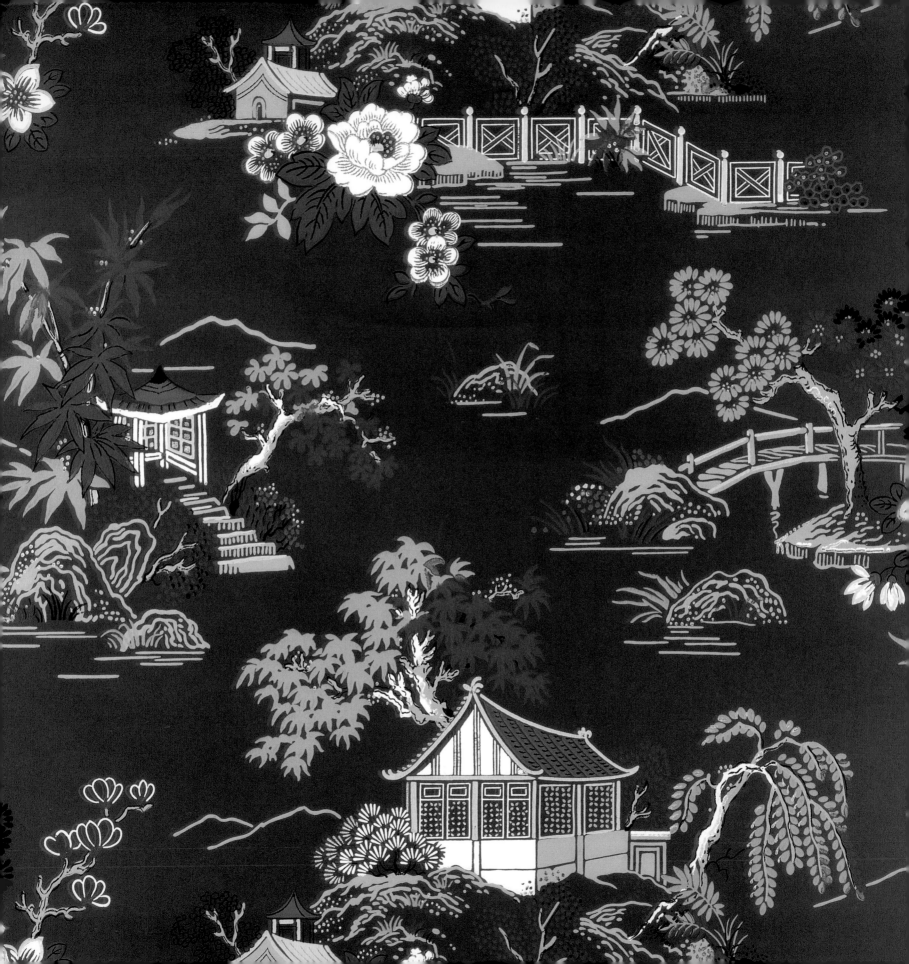

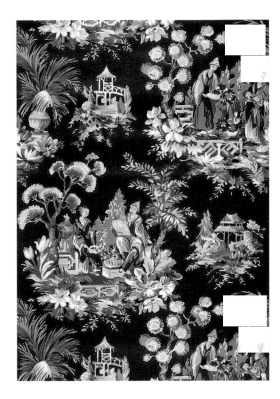

from 1948, showcased a view of Grand Teton National Park seen through printed window mullions.

Along with photographic murals, wallpaper manufacturers created landscape panels printed in a technique similar to blue-printing, which produced white lines on a dark ground or vice versa. At the opposite extreme from the literal-minded panoramas are the emblematic landscape papers in which different geographical zones and eco-niches are tagged by symbolic vegetation, creating a sort of shorthand of geographical and emotional indexing. So, for example, the umbrella pine, oleander, and the cypress are used to "place" Italian scenes. The palm tree, of course, has long been symbolic of the tropics, as have the agaves, pineapple, orchid, and acanthus. "Old roses," tulips, morning glories, and especially hollyhocks signify English gardens. Bamboo instantly connotes the Far East. Such laconic substitutions for grandiloquent, detail-laden scenic landscapes became especially dominant in the more conservative wallpapers of the 1950s through the 1970s. Less psychologically compelling and more forgiving of eclectic furnishings than their panoramic analogues, these metonymical designs have become the haiku of scenic wallpapers: concise, but infinitely suggestive. ◉

⬥ Even in 1952, at the height of America's infatuation with contemporary design, chinoiserie wallpapers, such as this one from Canada, commanded a vast following.

◄● Brilliant jewel tones and dramatic contrasts were distinctive of French wallpapers from the late 1910s and throughout the 1920s.

9 High Art
FROM BAUHAUS TO POP, WITH STOPS ALONG THE WAY

Niki de Saint-Phalle, creator of "Nana," was one of a number of artists whose wallpaper designs were featured by the German firm Marburger Tapetenfabrik in 1972.

Those who've got it, flaunt it. Those who don't, get wallpaper. The "it" in question is an original work of art: a tapestry, painting, sculpture, or precious woods and costly architectural detailing. A product of mechanical means of reproduction, wallpaper has an inherently split personality, at once genuine article and fraudulent pretender. As paper, it can be printed, cut, glued, and applied to surfaces. As pattern, it can replicate the appearance of totally unrelated objects. Treated with the respect accorded valuable works of art, it can become the medium for artistic expression, rivaling the level of their technical achievement; the excellence and uniqueness of their design; and, on occasion, matching their expense. At the same time—and here is the source of its endearingly satisfying subversiveness—wallpaper makes a superb "con artist." Given contemporary printing and screening techniques, it can be made to replicate the most arcane and refined works of art—at a cost that puts it within reach of all but the most indigent.

The most blatant and hence fabulous fakes belong to the genre of trompe l'oeil or "fool-the-eye" wallpapers. With a pedigree that goes back to their very inception as pseudo-tapestries, trompe l'oeil patterns draw on the conventions of realistic painting to render the literal appearance of everything from architectural details to materials. As painted architecture, trompe l'oeil designs draw on an illustrious tradition that produced the apparently lofty and vaulted ceiling of the

⬧ This trompe l'oeil pattern, made in Chicago, IL, reproduces a hexagonal lattice of woven grass.

⬧⬧ In 1956, F. Schumacher issued Frank Lloyd Wright's prestigious Taliesin Line, which included coordinated textiles and wallpapers and drew heavily on the architect's abstract geometric patterns of the 1930s.

➡ This 1947 pattern, designed to look like soft, buttoned upholstery, was also available with a plain, pink ground.

Sistine Chapel and countless Renaissance pilasters, niches, paneling, lunettes, door frames, and pediments. Painted by the likes of Michelangelo, Raphael, Veronese, Titian, and Tintoretto, these architectural features are rendered with such scrupulously articulated shadows and highlights that they trick the eye into reading flat surfaces as three-dimensional structures in wood, stone, or plaster.

Throughout the whole of the nineteenth century and well into the twentieth, as the technology of cheap and attractive paper production improved, wallpaper performed an often overlooked but important social function. It made accessible and attainable to an unprecedented broad sector of the European and American urban population the hitherto aristocratic ideal of the home as private haven. In this sense, it played a humble though real role in the gradual process of the democratization of taste and the leveling of markers of social distinction that accompanied the emergence of the private individual onto the stage of European history. In studying this phenomenon, Walter Benjamin, the German theoretician of modernism, had noted that as early as the reign of Louis Philippe in France (1830–1848), the commercial bourgeoisie invented the home as a space distinct from and opposed to the place of work. "The private individual, who in the office has to deal with reality, needs the domestic interior to sustain him in his illusions," wrote Benjamin in his essay "Paris, Capital of the Nineteenth Century." "This necessity is all the more pressing since he has no intention of allowing his commercial considerations to impinge on social ones. In

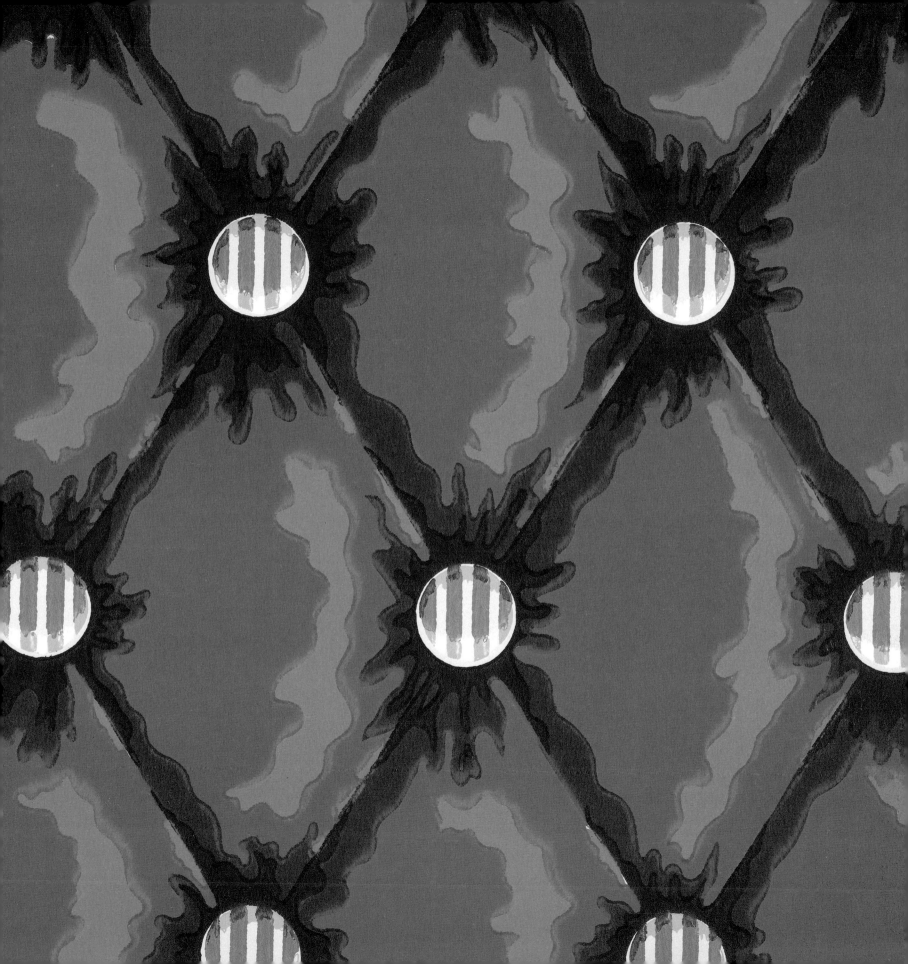

the formation of his private environment, both are kept out. From this arise the phantasmagorias of the interior—which, for the private man, represents the universe. In the interior, he brings together the far away and the long ago. His living room is a box in the theater of the world."

The rarified genre of scenic wallpapers of Chinese or domestic provenance that appeared in Europe in the eighteenth and early nineteenth centuries "theatricalized" the home. It brought the world into the home, and, through floral and vegetal imagery, recalled the edens from which humanity had been banished. Beginning in the 1690s, traders with the British East India Company brought the first Chinese papers to Europe and to the American Colonies, immediately igniting a craving for these superb accoutrements. Nothing then available domestically could rival the artistry of the Chinese product: masterfully hand-painted in many hues of luminous gouache or tempera, the multi-paneled sets (running to as many as forty segments) were conceived on a grand scale. The nonrepeating, continuous patterns fell into three broad categories: scenes of flowering trees, rocks, and birds; scenes of people and flowering trees; and, finally, "genre" scenes depicting the Chinese going about quotidian rituals and affairs. By the middle of the eighteenth century, the demand for these exquisite papers far exceeded their supply, prompting European manufacturers to attempt their own versions. The pseudo-Chinese wallpaper was born, and with it, "chinoiserie," an extraordinarily prolific and enduringly popular genre of décor. The taste for every kind of Orientalist conceit and gewgaw ran the gamut from a fascination with the harems and odalisques of Delacroix to a virtually inexhaustible craving for Chinese silks and Indian paisleys. The most lavish scenic wallpapers—such as "Les Zones terrestres" that showcased an Algeria-based Orientalism, "Le Brésil," "L'Hindousan," "Procession chinoise," and even "Les Fêtes de la Grèce et Jeux olympiques"—were destined

for the walls of consular and imperial administrators and aristocratic travelers nostalgic for the exotic landscapes of their sojourns. By turns waxing and waning, the popularity of chinoiserie wallpaper has remained ever since.

About the same time that Chinese fakes appeared on the market, John Baptist Jackson, a British wood-engraver, pioneered scenic papers based on subjects drawn from classical antiquity and on the landscape paintings of Claude Lorrain, Salvator Rosa, Nicolas Poussin, Jean-Antoine Watteau, and Giovanni Paolo Pannini. Hand-painted and created for an elite clientele, these high-art-based designs eventually passed into mass production. Many of the images on these wallpapers were derived from published engravings of heroic paintings and ancient monuments and ruins. At a time when genuine or artificial ruins were all the rage in private gardens, trompe l'oeil wallpapers of crumbling temples and broken colonnades made it possible to install instant ruins in the home.

The same impulse that prompted the fascination with ruins as the surviving fragments of once-glorious civilizations inspired the taste for vignette wallpapers. In contrast with the all-encompassing scenic wallpapers, which created a seamless fiction of an alternative reality, the vignettes reproduced a variety of often discontinuous images on a single wall. Framed in cartouches, arabesques, or scrollwork, the individual vignettes juxtaposed scenes based on the *fête galante* with images of ruins, pastoral idylls, and technological specimens such as mills and bridges. This association of spatially and culturally distinct phenomena invited the resident to see himself as the center of civilizational flux, as the single constant in the evanescent flow of historical time and space.

The Swiss Kinetic artist Jean Tinguely contributed this design to the Marburg firm's series of museum quality wallpapers.

In 1948 the New York firm of Katzenbach & Warren produced "Arbre en Fleur," a hand-screened mural designed by Henri Matisse and "A Piece of My Workshop," by Alexander Calder.

A PIECE OF MY WORKSHOP

Calder '48

While the vignette-oriented wallpapers refer to high art in the way of "citations" of well-known museum pieces, some papers were and continue to be the direct result of artistic input by fine artists themselves. Beginning in the late 1940s, a number of "boutique" wallpaper firms commissioned fine artists to design top-end wallpapers, usually in the form of murals. Before joining *New Yorker* magazine in 1941, Russian-born cartoonist Saul Steinberg designed a wallpaper entitled "Views in Paris," produced by Piazza Prints in 1946, and followed, in 1950, by his witty "Wedding" and "Trains." In 1948 the visionary firm of Katzenbach & Warren of New York published a limited edition of screen-printed murals designed by Henri Matisse, Joan Miró, Roberto Matta, and Alexander Calder, as well as a stunning pattern, "Byzantine Curtains," by the designer Ilonka Karasz. The following year, Calder produced another design for both fabric and wallpaper for Laverne Originals of New York. The

British Lucienne Day took up where these artists left off. In a series of brilliantly inventive patterns, she improvised on the themes of Steinberg, Miró, Klee, Calder, and the sculptures of Naum Gabo. Day's designs featured calligraphic lines in impeccable tension and balance, dynamic rhythms, and unusual color combinations that have since become synonymous with the best of 1950s design.

Wallpaper became an especially ambiguous meeting ground between art and industry during the 1960s, when ideas on color, pattern, theme, and motif were liberally exchanged among artists working in every discipline. Experiments in pop, op, kinetic, and hard-edge art spilled over into fashion and interior design, and artists like Andy Warhol, Robert Indiana, Victor Vaserely, and Peter Max worked both sides of the fine/commercial art divide. The brash young artists in the pop camp embraced the messy vitality of mass-produced objects, of vernacular art, advertising, film, and the vibrant vulgarity of city streets. An irreverent idiom jointly coined by commercial and fine artists, the language of pop was ironic, witty, and brash. Pop interior design could not care less about enduring good taste. The modern, according to pop, was all about instant gratification, wish fulfillment, and self-expression. Drawing on myriad sources, the iconography of pop did not discriminate between the Union Jack and a box of Cracker Jacks, whether on the walls of New York's MOMA or of a hippie pad in Haight-Ashbury.

Otmar Alt's "The Happy Cow" was produced by Marburger Tapetenfabrik, Kirchain, Germany.

An edition of pop-art inspired papers offered by United Wallpaper in 1967–68 comprised large-scale, psychedelically colored florals, paisleys, and geometrics on revolutionary strippable, pre-pasted vinyl. In 1966 Andy Warhol silk-screened his own wallpaper and called it "Cow" even as Roy Lichtenstein–inspired cartoon images and Jasper Johns–derived American flags were commercially produced. The high-art trend continued into the early 1970s. In Germany, the Marburger Tapentenfabrik offered "xartwall," a line of wallpapers designed by the artists Otmar Alt, Werner Berger, Allen Jones, Peter Phillips, Niki de Saint-Phalle, Jean Tinguely, and Paul Wunderlich. Though not inexpensive, these wallpapers and their many cheap knock-offs did much to transform the home into a private art gallery.

As a counterpoint to the tongue-in-cheek, everything-goes, pop and op aesthetic, a number of new design firms were committed to the aesthetic elitism of the "international style." Designers such as the Americans Hans and Florence Knoll, Jack Lenor Larsen, and Herman Miller; the British Robin and Lucienne Day; the German Eberhardt and Wolfgang Schnelle; the Italian Mario Bellini, Marcello Nizzoli, and Ettore Sottsass; the Finnish Merimekko; and the Danish Arne Jacobsen brought "good" contemporary design — a clean-lined functionalism and a rationalist, minimalist aesthetic — to the workplace and to the home. Their agenda embraced the utopian project to imbue private and public spaces with simplicity, refinement, discipline, and logic. In this respect they were continuing the legacy not only of the Bauhaus modernists but also of their intellectual forebears, the designers of the Arts and Crafts movement in Britain and the Craftsman movement in the United States.

Both the nineteenth- and mid-twentieth-century iterations of the "less-is-more" aesthetic cultivated, with varying emphases, wallpapers that minimized figuration and maximized texture. This emphasis is reflected in the considerable prestige accorded by these designers to the genre of trompe l'oeil. Gustav Stickley, for example, endorsed the discriminating use of papers in the Craftsman home. Both in *The Craftsman*, his official publication, and in his New York department store, Stickley offered a range of trompe l'oeil patterns and materials, including washable "Sanitas" oilcloth papers with "plain and glazed tile effects for bathrooms, kitchens, and pantries." Contemporary design continues to favor these optical illusions. Various parts of architectural features such as cornices, capitals, pilasters, and moldings are printed separately and sold by the yard so they may be cut out and applied to create ornate structural effects with the drama of stage settings. Other "imitation" papers re-create wood grain, fabric swags, tufted cushions, iron grillwork, grasscloth, drapery, leather, tortoise shell, and even lace. As wallpaper gurus Lois and William Katzenbach argue in their *Practical Book of American Wallpaper*, "textured papers representing actual building materials make very appropriate subject matter for walls." And why not?

If clothing the body is worthy of haute couture, clothing the walls, which enclose the body, should merit nothing less than the artistry, genius, and craft that produces museum masterpieces. ●

10 Bringing Up Baby

MOTHER GOOSE AND OTHER KID STUFF

"Oranges and Lemons Say the Bells of St. Clemens," by Dorothy Hilton, dates from 1902.

As far as wallpapers go, the British invented childhood. Their version was a fantasy of pale girls in floaty smocks and kidskin slippers skipping through rose-choked gardens and of tow-headed boys in sailor suits rolling hoops down cobbled streets. It was a vision of tea parties with cream cakes, outings on spotted ponies, and fairy tales filled with knights and dragons and flaxen-haired damsels and dishes running away with spoons. Since the third quarter of the nineteenth century, when the British Walter Crane first had the idea of transposing his illustrations to wallpaper, children's rooms have become giant storybooks. Elaborately detailed and filled with sinuous curves and flowing lines, Crane's illustrations tapped into the romance of the Middle Ages for their "local color" and into the aesthetic sensibility of art nouveau.

The credit for this aesthetic properly belongs to Crane's printer and engraver, Edmund Evans. In or about 1865, Evans had reached the limit of tolerance for the abysmally low artistic level of visual materials for children. He resolved to put on the market children's books that would be not only beautifully written but also furnished with superb drawings by the finest artists and illustrators of the time, such as Kate Greenaway, Randolph Caldecott, and of course, Crane.

Crane's contribution to the beautification of children's lives lies both in producing books that were works of art and wallpapers that were worthy of the best

⬧ White poodles serenade dancing zebras in this wacky children's wallpaper.

⬧⬧ The Joliet Wallpaper Mills manufactured zany nursery wallpapers, such as this waterfast, light-resisting pattern of domestic and zoo animals.

➤➤ A cast of elves, bunnies, beetles, frogs, and mice decorates this fine example of the children's frieze patterns produced in England in the 1920s.

available in the "adult" market. Crane's decision to make the leap from page to wall was triggered by an act of piracy on the part of an American wallpaper manufacturer who had stolen one of his illustrations in 1875. Crane realized not only that there was a new market for his designs but also that the shared technology of book illustration and wallpaper design made possible the seamless migration of his images from one medium to another. In both instances, the artist's original ink drawings were photographed, transferred onto wood, and then engraved on as many blocks as there would be colors. Depending on the design, the resulting images featured bold, black outlines filled in with six or more flat colors.

The last two decades of the nineteenth century were the "golden age" of illustrated children's books. They were equally glorious for the range and quality of children's wallpapers. In addition to Crane's various designs, including the popular nursery paper "The House that Jack Built" for Jeffrey and Company of London, Kate Greenaway's "Playtime," "Under the Window," and the "Almanack 1893," illustrations of the month, were produced in rapid succession by the British wallpaper firm of David Walker. Randolph Caldecott's six-color illustrations for the books *Baby Bunting, The Diverting History of John Gilpin, The Three Jovial Huntsmen,* and *Hey, Diddle, Diddle* were available both in wallpaper patterns and in ornamental friezes. The British Dorothy Hilton and the Americans Howard Pyle, Newell Convers Wyeth, and Grace Lincoln Temple created evocative renditions of classical fiction and nursery rhymes.

↑ Circus animals and performers have been a staple of twentieth-century nursery wallpapers.

➤ This sophisticated 1950s design for a child's room recalls the work of Finnish designer Marija Isola.

The appeal of these exquisite wall hangings was keenly appreciated by contemporary designers and retailers. In touting the "charm and character" of their products, manufacturers eagerly pointed out that the boldly colored nursery papers were "a continual delight not only to the little people but to the grown-ups as well." The source of their charm was complex. The best of these nineteenth-century wallpapers transported children into magical realms of the imagination. From the moment children awakened, they were surrounded by images of radiant and beautiful beings, flowers, and animals. However simple or repetitive, the images on the walls suggested stories heard, read, or remembered, and invited the child to "fill in the blanks" with creative improvisation. Children amused themselves by studying the iconography and the shapes, and "entering" into the stories that unfolded all around them.

Space—its shape, texture, light, and airiness—has the capacity to mold the soul. Colors, physiologists tell us, have the power to shape emotions: to soothe, to excite, to elevate, or to depress in a complicated, psychochromatic calculus. Finally, the images themselves are potent transmitters of cultural information: they have the capacity to distract, stimulate, entertain, and teach. In these respects, children's wallpapers are potent catalysts for formative experiences. Some, such as those filled with images taken from fairy tales, nursery rhymes, legends, and religious traditions, immerse children in the roots of their culture. Others are drawn from

MARIGOLD *Jealousy*

BRIG

LILA

First Lo

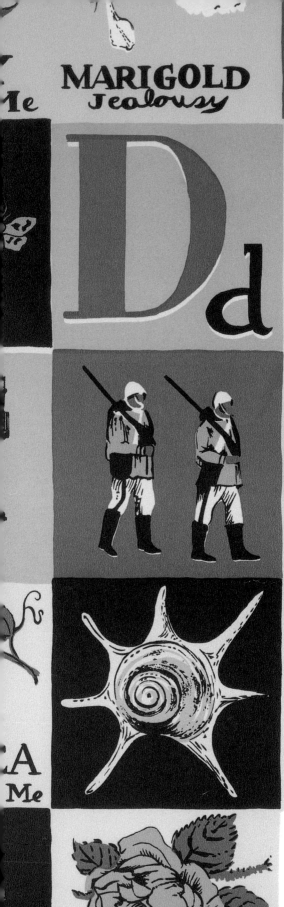

Dd

NARCISSUS *Egotism*

L

LILY OF T

VALLEY
I think of

CROCUS *Gladness*

VIOLE
Faithfuln

A

Me

Y

Katzenbach and Warren produced this
alphabet wallpaper in 1955.

contemporary myth. These celebrate dominant pop characters of various periods, icons of heroism and pulchritude that cover the whole gamut of cartoon, storybook, and movie personalities, from Superman and Barbie to Babar and Eloise.

The demand for nineteenth-century storybook and nursery rhyme wallpapers—reissues, reproductions, or derivations—has continued unabated throughout the twentieth century. In part, their enduring popularity can be attributed to our cultural attachment to the idea of childhood as a privileged time of life, innocent and spared the constant intrusions and demands of brute survival. Because we clothe our image of childhood in a veil of nostalgia, we gravitate toward images that speak of a time and place beyond the reach of the present. This "once upon a time" of myth is best conveyed by the anachronistic visions of childhood and childhood's fantasies that are enshrined in the classic designs of Greenaway, Crane, Caldecott, and the other fine artists from the golden age of children's book illustration.

At the same time—especially since World War II—children's wallpaper has shown a tendency to plug into contemporary culture and contemporary conceptions of childhood. The "Boomer Babies" of the 1950s, for example, were subjected to intensive though most likely totally inadvertent gender programming through gender-coded wallpaper designs that identified girls with pastel colors and the "feminine" iconography of bows, flowers, dots, hearts, ladybugs, butterflies, and stars, while assigning a "masculine" character to primary colors and patterns featuring stripes, bugs, dogs, machines, and sports. A dual realm of "separate-but-equal" subcultures has been the norm in wallpaper design through the second half of the twentieth century. Though the English language lacks grammatical gender, wallpaper designers seem intent on assigning gender to visual icons. So, for example, boats, cowboy boots, fire engines, gorillas, jungle animals, and dinosaurs are masculine, while teddy bears, dolls, ballerinas, angels, flowers, and ice cream cones are feminine. With the exponential proliferation of television cartoons for children in the 1980s and 1990s, fictional characters and plots have also taken sexually divergent tracks. While certain Walt Disney images—Bambi, Mickey and Minnie Mouse, for example—and Sesame Street characters enjoy a sort of unisex appeal, others, such as the Ninja Turtles and the Powerpuff Girls never cross gender lines.

A striking development in children's wallpaper design of the 1990s has been the emergence of "spiritual" thematics, either in all-over patterns or in decorative friezes, murals, or ornamental strips. Religious didacticism and patriotic imprinting appear to be agendas exclusively limited to American mass-market wallpapers. Though devoid of humor and generally lacking visual imagination, these earnest and well-intentioned designs speak more directly and unself-consciously to that deep-seated, almost primitive impulse that impels us to decorate the walls of our habitations with images and designs of our history and

A swing band of diapered babies cavorts across this Wallpaper Mills frieze.

This "Waterfast" nursery paper from the 1930s was manufactured by Peacock Decoration, Inc.

wishes for our future. These powerful mythical images speak of a profound and persistent craving for icons that help us project order on what otherwise might be chaos, to derive sense and plot from what appears to be random, to maintain continuity in the face of discontinuity.

By surrounding ourselves with familiar stories and, perhaps even more significantly, with pattern, we seek to reinforce the impression that our lives manifest a constant and reassuring rhythm. In short, like the all-encompassing panoramic wallpapers of the eighteenth and nineteenth centuries that launched this potent genre of interior décor, the best children's wallpaper functions as a surrogate womb: an elective environment of images, colors, and patterns that nurture and sustain us in the midst of an assaultive reality. Or, as children's wallpaper again graphically suggests, the personality of the walls is a projection of the personality of their tenant. When all is said and done, we are our wallpaper. ●

Bibliography

Ackerman, Phyllis. **Wallpaper: Its History, Design and Use**. New York: Tudor Publishing Company, 1938.

Battersby, Martin. **The Decorative Twenties**. Revised and edited by Philippe Garner. New York: Whitney Library of Design, 1988.

——————. **The Decorative Thirties**. New York: Walker and Co., 1971.

Bosker, Gideon, Michele Mancini, and John Gramstad. **Fabulous Fabrics of the 50s (And Other Terrific Textiles of the 20s, 30s, and 40s)**. San Francisco: Chronicle Books, 1992.

Clark, Jane Gordon. **Wallpaper in Decoration**. New York: Watson-Guptill Publications, 2001.

De Salvo, Donna, and Annetta Massie. **Apocalyptic Wallpaper: Robert Gober, Abigail Lane, Virgil Marti, and Andy Warhol**. Columbus: The Ohio State University, 1997.

Duncan, Alastair. **Modernism: Modernist Design 1880–1940**. Minneapolis: The Northwest Collection Norwest Corporation, 1998.

Fiell, Peter and Charlotte, editors. **Decorative Art—1900s & 1910s**. Köln: Taschen, 2000.

Garner, Philippe. **Sixties Design**. Köln: Taschen, 2001.

Greysmith, Brenda. **Wallpaper**. New York: McMillan, 1976.

Hapgood, Marilyn Oliver. **Wallpaper and the Artist: From Dürer to Warhol**. New York: Abbeville Press, 1992.

Hoskins, Lesley, editor. **The Papered Wall: History, Pattern, Technique**. New York: Harry N. Abrams, Inc., 1994.

Jackson, Lesley. **Robin & Lucienne Day: Pioneers of Modern Design**. New York: Princeton Architectural Press, 2001.

——————. **Twentieth-Century Pattern Design: Textile & Wallpaper Pioneers**. New York: Princeton Architectural Press, 2002.

Justema, William. **The Pleasures of Pattern**. New York: Van Nostrand Reinhold Company, 1982.

Katzenbach, Lois and William. **The Practical Book of American Wallpaper**. Introduction by Nancy V. McClelland. Philadelphia and New York: J.B. Lippincott Company, c. 1951.

Kosuda-Warner, Joanne. **Kitsch to Corbusier—Wallpaper from the 1950s**. New York: Cooper-Hewitt Museum, 1995 (museum guide).

Kosuda-Warner, Joanne, with Elizabeth Johnson, editor. **Landscape Wallcoverings**. New York and London: Scala Publishers in association with Cooper-Hewitt, National Design Museum, Smithsonian Institution, 2001.

Lang, Donna and Lucretia Robertson. **Decorating with Paper: Creative Looks with Wallpapers, Art Prints, Gift Wrap, and More**. New York: Clarkson Potter Publishers, 1993.

Lynn, Catherine. **Wallpaper in America from the Seventeenth Century to World War I**. Foreword by Charles van Ravenswaay. New York: W.W. Norton & Company, Inc., 1980.

McLelland, Nancy. **Historic Wall-papers from Their Inception to the Introduction of Machinery**. Philadelphia: J.B. Lippincott, 1924.

Nouvel-Kammerer, Odile, et al. **French Scenic Wallpaper 1795–1865**. Paris: Flammarion, 1991.

Perez-Tibi, Dora, and Eric Mezil. **Raoul Dufy: La Passion des Tissus**. Vesoul: Clé-Librairie Klincksieck, 1992.

Schoeser, Mary. **Fabrics and Wallpapers: Twentieth-Century Design**. New York: E.P. Dutton, 1986.

Teynac, Françoise, Pierre Nolot, and Jean-Denis Vivien. **Wallpaper: A History**. New York: Rizzoli, 1982.

Index